lonely planet

50 Museums

TO BLOW YOUR MIND

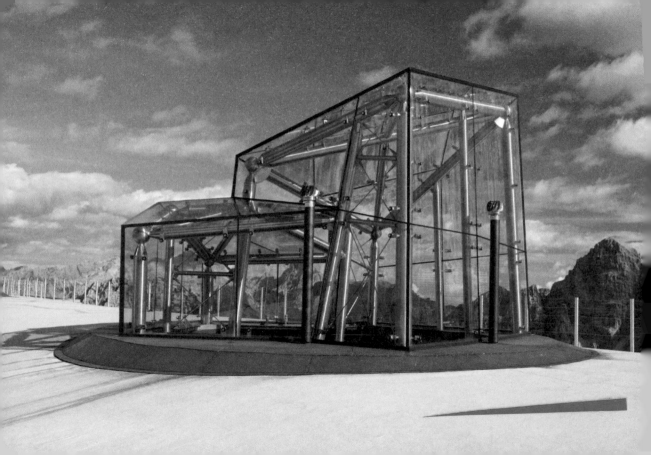

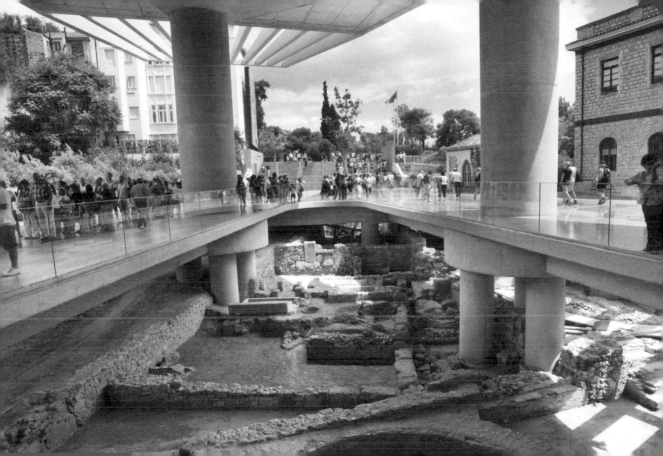

Contents

Things that go //
Science & technology museums

Peculiar passions // Quirky museums

Introduction

It starts innocently enough. You notice the interesting motif on a beer bottle top. You put it in your pocket and when you get home, flip it into a bowl on your bookshelf. Another day, another beer, another bottle top catches your eye. It gets flipped into the bowl too.

Six months later you've attached 4563 bottle tops (some donated by friends who think your obsession is quirky) to one wall of your living room. You start a website documenting your collection.

One year on: your friends are often busy, but so are you, and in any case, the bottle-top collection has sky-rocketed, your bottle-top collecting web connections have inspired you

and the display room (your ex-garage) suddenly takes on a new guise: Bottle Top Museum.

We've pretty much left sane-land, we're now in the land of ooooh in the city of ahhhhhh; firmly in the country of collector mania.

This is basically how every museum begins.

And really, thank the stars for these obsessives, these documenters of the great and trivial, these people who want to show us all something wonderful about their collections and share the insights into humankind each of them illuminates. They might be the easiest way for aliens to get to know us, if not for us to learn about ourselves. Oooooh ... alien artefacts. There's a collection to start... maybe you'll visit soon.

The Museum...
relationship...
Museum off...
collection...

Relationships grew from a traveling exhibition revolving... ...ins. Unlike 'destructive' self-help in obsactions for recovery... ...to overcome an emotional collapse through creat... by con...

Whatever the motivation for donating person... ...things – be it sheer exhibitionism, therapeutic relief, or simple curiosity – people embraced the idea of exhibiting their loved legacy as a sort of a ritual, a solemn ceremony. Our societies oblige us with our marriages, funerals, and even graduation farewells, but only... any formal recognition of the demise of a relation ship despite its strong emotional effect. In the words of Roland Barthes in *A Lover's Discourse* "Every passion, ultimately, has its spectator... (some is) no amorous oblation without a final theatre."

Conceptualized in Croatia, the Museum has since in... ...internationally amassing an amazing success. Although often colored by personal experience local... ...y and history, the exhibits presented here form universal patterns offering us to discover them and... ...r comfort they can bring. Hopefully they can also inspire our personal search for deeper insights and... ...in our belief in something more meaningful than random suffering.

Then & now // History museums

15 DIONYSIOU AREOPAGITOU ST,
MAKRYGIANNI, ATHENS, GREECE
WWW.THEACROPOLISMUSEUM.GR

Acropolis Museum / Greece

SO HOW'S THIS NEW ACROPOLIS MUSEUM WORKING OUT?

Funny you should ask; extremely well. This hyper-modern, in situ museum is more than ten times the size of its predecessor and intertwines spectacular architecture with the display of surviving gems from the Acropolis.

ALL OF THE GEMS?

Controversially, the 'Parthenon Marbles', aka the 'Elgin Marbles', are still housed in the British Museum, so the display at the Acropolis contains a pointed gap where the marbles belong. And there are many other Parthenon marble artefacts scattered around the world, so be prepared for a few holes in the collection.

SO IF WE WON'T SEE THE FULL ASSORTMENT OF PARTHENON TREASURES, WHAT WILL WE SEE?

Among the triumphs of the museum's design are the glass walkways and floor-to-ceiling glass walls which allow visitors to walk right over the top of Acropolis ruins and look out on the slopes of the Acropolis, seeing 2000 years of history in its original context. Most of the collection is from the 5th century BC, though there are items from the Archaic and Roman periods as well.

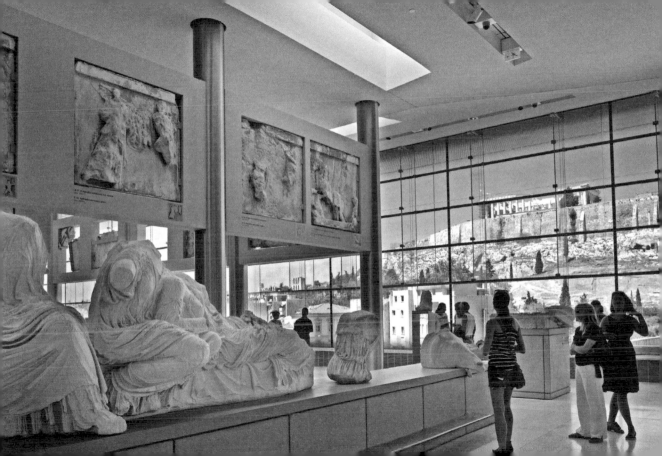

GREAT RUSSELL ST, BLOOMSBURY,
LONDON, UK
WWW.BRITISHMUSEUM.ORG

British Museum / UK

EVERY MAJOR CITY HAS THEIR OWN MUSEUM. WHY IS THIS ONE SO SPECIAL?

Hold on to your hat – this world-class, truly remarkable museum was opened in 1753 and houses a collection which spans more than two million years of human history, with show-stoppers like the Rosetta Stone, the world's largest collection of Egyptian mummies, a 36m-long Viking warship, and an actual Easter Island statue, to name just a few.

THAT SHOULD KILL AN HOUR OR TWO.

That is just the tip of the iceberg. The museum has about eight million works on display. Yes, people, eight million.

HOW DO I EVEN KNOW WHERE TO BEGIN?

The museum is laid out in exhibitions on culture, people, place and/or material. Tip: the Greeks and Romans feature heavily and you won't want to miss the Parthenon Sculptures. Otherwise known as the Elgin Marbles, these sculptures are part of the original Parthenon and Acropolis in Greece. If you're still unsure of how to proceed, the museum provides itineraries with highlights for those with an hour or three hours to spare; that should help narrow it down.

I'M THERE. ANYTHING ELSE I SHOULD KNOW?

Oh, yeah – we forgot to mention, it's all totally free!

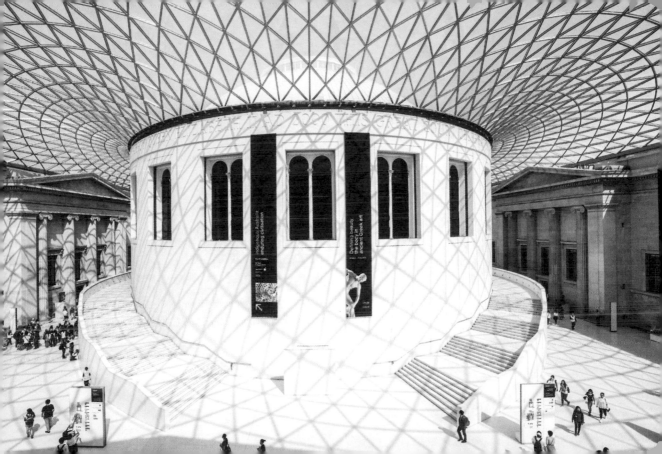

4 JING SHAN QIAN JIE,
DONGCHENG, BEIJING, CHINA
WWW.DPM.ORG.CN

Forbidden City / China

THE FAMOUS FORBIDDEN CITY, FORBIDDEN NO LONGER?

For more than 500 years the world's largest palace complex was the exclusive haunt of royal dynasties, but after a Republican coup overthrew the last Qing Emperor the complex was open to all.

SO WE CAN WALK IN THE FOOTSTEPS OF ROYALTY?

It's like stepping back in time. Crossing the 52m-wide moat that rings the complex takes you into the centre of the best-preserved ancient buildings in all of China.

WHERE DOES THE MUSEUM PART COME IN?

The buildings in the Forbidden City are collectively known as the Palace Museum and treasures and ancient royal artefacts are scattered through hundreds of rooms and galleries.

HOW DO WE APPROACH SUCH AN ENORMOUS SIGHTSEEING CHALLENGE?

See the City as divided into an outer and an inner court. Each is comprised of buildings with grandiose names like 'The Palace of Earthly Tranquillity'. Our tip for making the most of your time: wander unhurriedly through the endless halls and corridors and soak up the history at your own pace.

Goethe House & Goethe Museum / Germany

HIGHBROW!

Yeah, this is all about the time and place of a true renaissance man. Goethe House was the home where writer, statesman and all-round polymath Johann Wolfgang von Goethe grew up. It's an early 17th-century building – two in fact, combined into one by Goethe's father (who would also be Goethe, but let's call him 'dad' for the moment)...

... 'DAD' MAKES IT ALL SEEM A LITTLE... LOWBROW.

You won't think so when you see the fully-decked out baroque masterpiece in all its glory. It also has the writing desk used to pen Goethe Jnr's early works. Goethe Museum, next door, adds to the atmosphere with artworks from this period of his life as well as pieces inspired by his writing.

IT'S DEFINITELY A REFINED KIND OF EXPERIENCE, THEN.

There's probably not going to be many laughs, but this memorial links you back to a seriously impressive life. He wrote poetry, novels, scientific papers, plays, criticism ... he was famous even as a young man. Then he got busy as a statesman and scientist. A visit here and you'll probably wonder what you've been doing with your life.

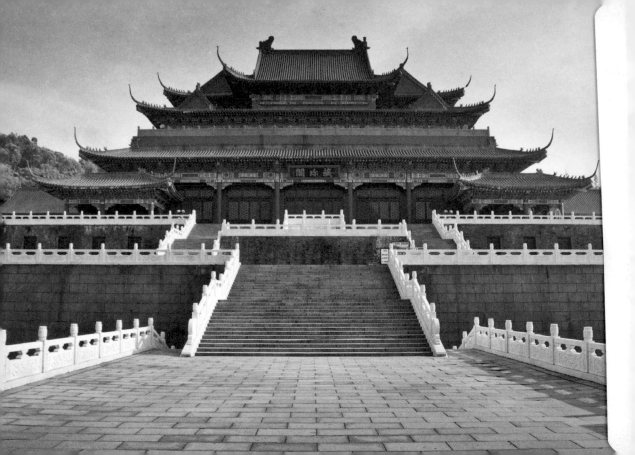

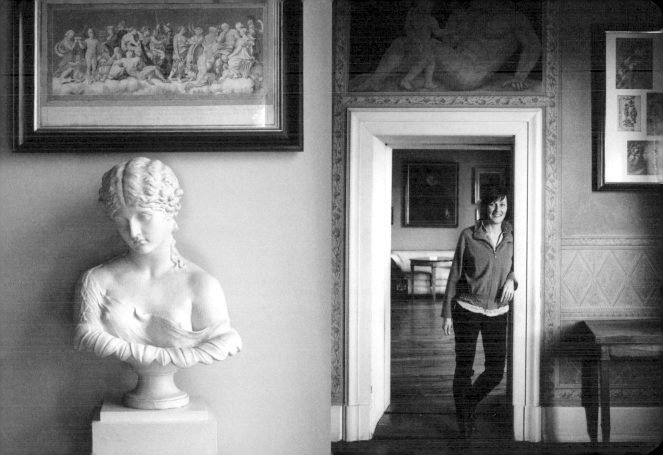

50

Imperial War Museum / UK

IT SOUNDS LIKE WE MIGHT LEARN SOMETHING HERE.

Among all the mind-bogglingly quirky museums in this book we have managed to include a few places that are of genuine historical significance as well as being remarkable and revealing. The Imperial War Museum is such a place.

WHAT'S IN STORE?

The museum has five separate localities all displaying warfare artefacts from British involvement in modern conflict. The main and most impressive location is housed at Lambeth Rd, where the large, central atrium hosts a Supermarine Spitfire suspended from the ceiling, displays of actual V1 and V2 rockets, and a Land Rover that was hit under a rocket attack in Gaza in 2006. Other extraordinary items include an Enigma code machine, the original note conveyed to the front line commander ordering the start of the battle of Ypres, and the bronze eagle from Reich Chancellery in Berlin.

WHAT ELSE IS A 'MUST SEE'?

Don't miss Churchill's War Rooms, the underground bunker where Churchill and his staff plotted the allied victory in World War II. The map room has remained completely intact and unchanged since the end of the war in 1945.

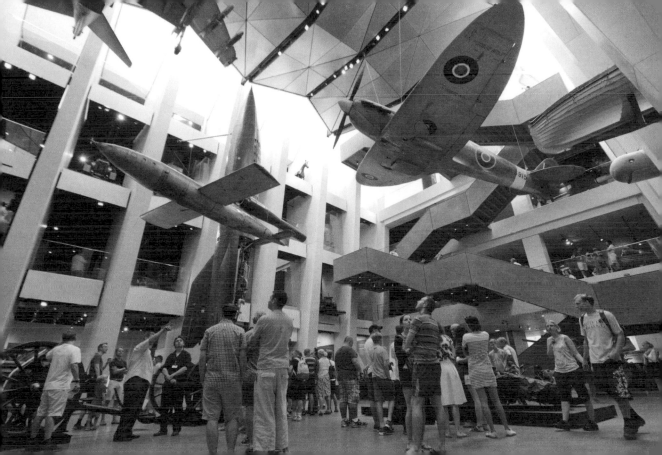

Museum of Alchemists & Magicians of Old Prague / Czech Republic

A MUSEUM THAT DOCUMENTS THE DARK ARTS? SOUNDS CREEPY.

Well, it wouldn't be the occult if it didn't make your skin crawl, right?

WHY WITCHES AND WIZARDS, AND WHY PRAGUE?

Prague has a long history of association with the darker side of human behaviour and belief. The 16th-century king Rudolf II was well-known for his passion for the mystical and mysterious and during his reign he went to town funding projects and obsessions of local occult alchemists and would-be sorcerers.

WHAT KIND OF WICKED MAGIC WILL I WITNESS?

Making it to the top of the exhibition's 16th-century spiral staircase could be your first trick. It is apparently the oldest spiral staircase in Prague and leads to the former workshop of Prague's premier Renaissance sorcerer, Edmund Kelley.

I CAN FEEL THE DARK MAGIC SWIRLING.

It could be the dummies dressed in period costume, the numerous glass vials and spell books, or even the homunculus in a bell jar that creates the spooky atmosphere, or maybe someone squeezed the giant bellows for the furnace and woke Boney, the sorcerer's skeleton assistant.

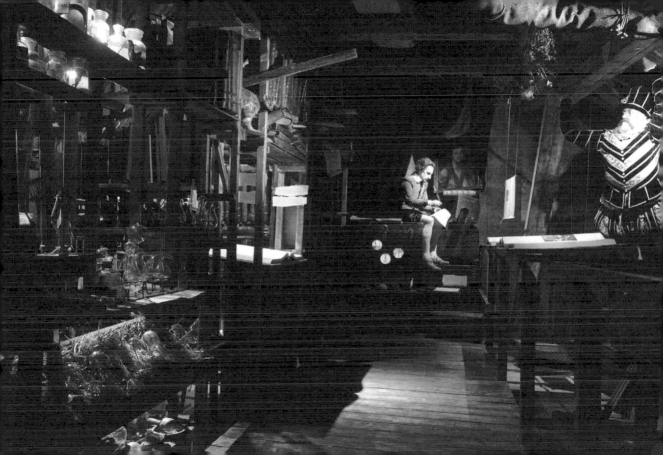

EXPLANADA DEL PANTEÓN MUNICIPAL
S/N, CENTRO, GUANAJUATO, MEXICO
WWW.MOMIASDEGUANAJUATO.GOB.MX

Museum of Mummies of Guanajuato / Mexico

EGYPTIAN-STYLE MUMMIES IN MEXICO?
Not exactly. The mummies at this Guanajuato museum have by no means been treated like kings.

THAT SOUNDS MYSTERIOUS.
The Guanajuato mummies were all evicted from their resting places in the mountains around the town when their families were unable to pay a 'grave' tax. In case the families came into a miraculous windfall and were able to afford reburial, the bodies were kept in an underground crypt. When some were exhumed and found to be well-preserved, the crypt gained notoriety; locals began to pay to view the bodies.

LIKE A LITTLE POP-UP MUSEUM?
Um, sort of. For many years bodies were just propped up on the walls but as the collection of bodies grew it was decided to exhibit them behind glass (as you see them today).

SOUNDS PRETTY GRUESOME.
It is. These mummies have not been wrapped, embalmed or made ready for display like the Egyptian mummies – they are as they were found. It can be confronting. There are murdered mummies (some with weapons still embedded in the corpses); babies; corpses still fully dressed in their burial outfits... Generally not one for the kiddies.

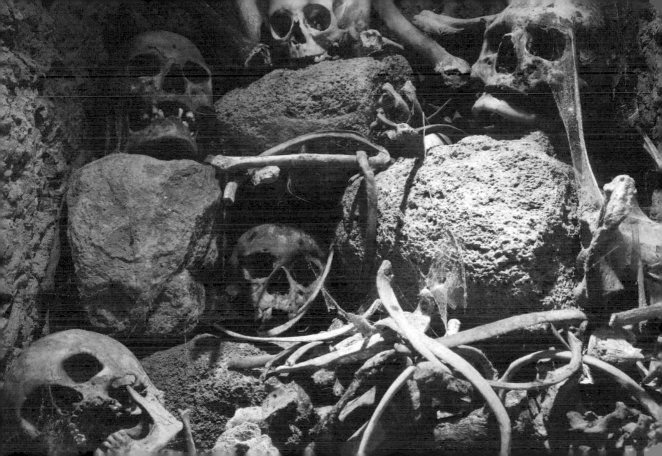

National Museum of Anthropology / Mexico

ANOTHER NATIONAL ANTHROPOLOGY MUSEUM.
If your travel companions are dragging their heels at the prospect of another boring anthropology museum then prepare to play your trump card. This is no two-bit, small-scale affair. Expect to be blown away by the world's largest collection of anthropological artefacts from the Mayan civilisations up to the Spanish conquest in the 16th century.

BLOWN AWAY? REALLY?
Enter the interior courtyard, where a giant stone edifice has water cascading atmospherically into a central pool, and prepare to step back in time. Twelve rooms encircling the courtyard trace the evolution of the Hispanic civilisations. Magnificent artefacts include the Rock of the Sun – an ancient crucifixion table from the Mexico-Tenochtitlan period; the 20-tonne giant stone head from the Olmec civilisation of 1200–600 BC; and the resplendent Mayan frescoes from AD 900–1250.

SOUNDS LIKE THE PAST IS COMING ALIVE.
With each room opening onto atmospheric gardens showcasing statues and temples, seemingly in situ, it's possible to imagine you're part of these impressively sophisticated cultures from thousands of years ago.

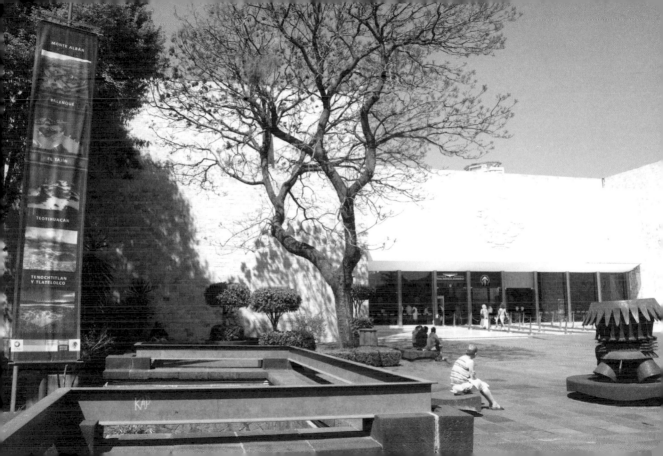

50

Old Operating Theatre Museum & Herb Garret / UK

I CAN FEEL THE CREEPY METER CREEPING UP.
Feel it go through the roof when you enter the Operating Theatre Museum. Separated from the wards of St Thomas's Hospital, the operating theatre (where operations on poor women were once conducted) was purpose-built to maximise light from above with a huge skylight and tiered seating for students. There's also some serious soundproofing.

SOUNDPROOFING?
Let's put it this way, the surgeons of the day (pre-1846 to be precise), had no anaesthetic or antiseptic. Operations were performed as swiftly as possible, with the patient's consciousness dulled by opiates or alcohol. Most operations were amputations. We'll leave you with that cheery thought.

CAN WE TALK ABOUT SOMETHING ELSE NOW PLEASE?
Sure, let's have a look at the old torture apparatus – oh, did we say 'torture'? We meant 'surgical' apparatus.

THIS IS NOT EASING THE QUEASINESS.
Perhaps a trip upstairs to the Herb Garret will help. This is the old apothecary where at least some attempt was made to invent something to relieve a patient's pain.

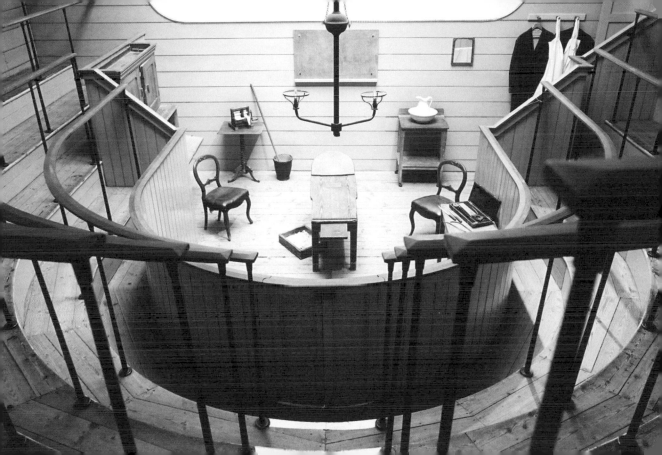

BUITENHOF 33, THE HAGUE,
THE NETHERLANDS
WWW.GEVANGENPOORT.NL

Prison Gate Museum / The Netherlands

WHAT DOES A PRISON MUSEUM IN THE 'INTERNATIONAL CITY OF PEACE AND JUSTICE' HAVE TO TEACH US?

Let's say...the changing notion of justice over time. When the prison opened in 1428 it held those accused and awaiting trial for months in cramped, dark cells. Incarceration was not considered a punishment until the 17th century.

SO THINGS GOT PRETTY UGLY UNDER PRISON GUARD.

The holding cells weren't even the half of it. Head up to the first floor to find out how roughly 'justice' was dished out.

I'M SCARED TO ASK; WHAT'S UPSTAIRS?

The floor above the original jail cells was reserved for torture. The chambers are lined with pain-inducing devices that boggle the mind, and to further compound the horror, the the walls were deliberately built thin so that cell mates were forced to suffer through the screams of those being tortured.

GUILTY UNTIL PROVEN INNOCENT IT SEEMS.

Have a read of the displayed narratives of some of the crimes involved – there are elaborate treason attempts and intricate schemes aimed at embezzlement and corruption. We wonder how punishment as a deterrent worked out...

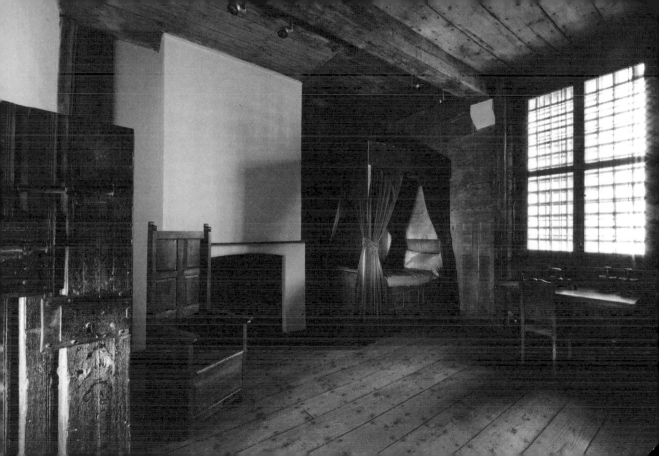

13 LINCOLN'S INN FIELDS,
LONDON, UK
WWW.SOANE.ORG

Sir John Soane's Museum / UK

SIR JOHN SOANE? NEVER HEARD OF HIM.
Soane was the son of a London bricklayer who grew up to be an architect. So what, right? Well, things got interesting when he married into money and began collecting art and odd curiosities from around the world. He packed his home with his beloved artefacts and requested that when he die the house be left as it was. It has been.

ECCENTRICITY ABOUNDS – HOW VERY BRITISH.
The heritage-listed house is crammed with Soane's genuinely amazing artworks and quirky rarities. The canopied dome of the house draws light down into a crypt stacked with statues, paintings and drawings – among which are architectural drawings by Christopher Wren. The upstairs rooms were Soane and his wife Eliza's private quarters, preserved almost exactly as they were when inhabited.

NONE OF THIS SOUNDS TERRIBLY UNUSUAL.
Oh, did we forget to mention the private quarters are crammed with models of Pompeii, Paestum and other ancient sites? There's a hieroglyphic sarcophagus; copies of slave chains; and a tiny room mocked up to resemble a monk's cell. Now that's a bit weird.

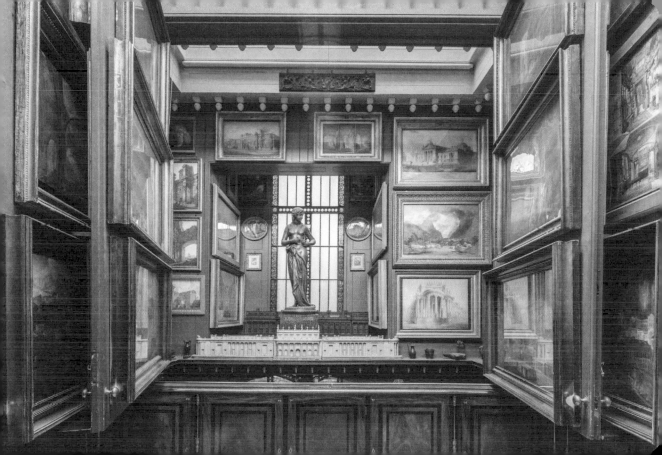

HERRENGASSE 16, GRAZ, AUSTRIA

WWW.MUSEUM-JOANNEUM.AT/EN/

STYRIAN-ARMOURY

Styrian Armoury / Austria

ANOTHER SWEET, HEART-WARMING COLLECTION I GUESS?

This is all about steel. Steel shaped into weapons of mortal destruction. And protection. But mostly destruction.

WE AREN'T VERY GENTLE REALLY, ARE WE?

Someone always has a beef with someone. The armoury dates back to the mid-17th century, built as an arms storehouse for the seemingly constant battles against the Ottoman Empire and Hungarian rebels.

AND WHAT EXACTLY GOT STORED?

There are more than 30,000 pieces of kit here – suits of armour, rifles, bullet moulds, two-handed swords, pallashes, couses, morning stars, mortars...

I HAVE NO IDEA WHAT YOU'RE TALKING ABOUT.

You'll get the point once you're here. The collections are presented in austere, hyper-organised displays (military-style, strangely enough!). Your only worry would be if the army of hollow armour took up arms and got angry.

NICE IMAGE. NOT.

You'll be fine. It's a great exploration of warfare, in many ways tracing the transition from medieval hand-wielded weapons to explosives – guns and cannons.

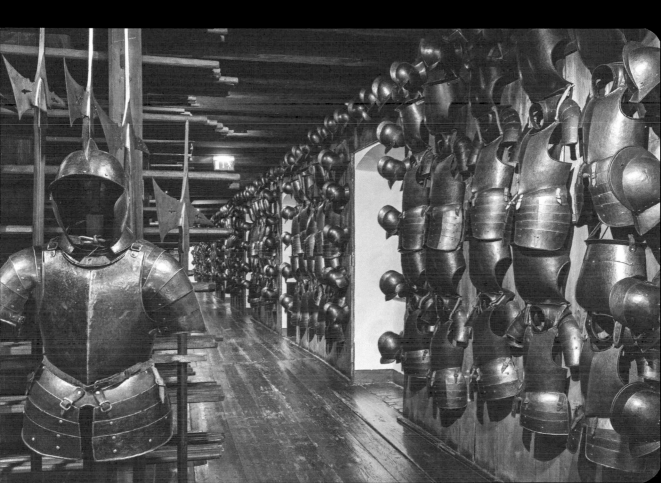

SINGEL 449, AMSTERDAM,
THE NETHERLANDS
WWW.TORTUREMUSEUM.NL

Torture Museum / The Netherlands

I'M IN THE MOOD FOR A LESSON IN ABJECT CRUELTY FROM THE MIDDLE AGES.
Be prepared to have your belief in the basic good of human nature severely tested. The exhibits here at the Torture Museum are mind-blowing, stomach-churning, gobsmacking. You'll find it difficult to believe how creative we can be when it comes to finding ways to make our own kind suffer.

OUCH. OUCH MULTIPLIED BY A MILLION.
Here are the tools public authority used to exercise its power over the people in the most gruesome and arbitrary of ways – until surprisingly recent times, just 200 years ago.

I'M THINKING OF PULLING OUT OF THIS LESSON.
The exhibits are a visceral experience; take the 'Skull Cracker', or 'Head Crusher' – a metal skull cap connected to a metal plate that sat beneath the victim's jaw, when the handle was turned the cap and plate moved closer till eventually things started to go seriously wrong – think broken bones and eyes popping from the skull.

I'M FEELING ILL.
It doesn't get any easier. Tools like the 'Hanging Cages' and the 'Heretic Fork' make the guillotine look positively humane. A stiff drink is in order when you make it out.

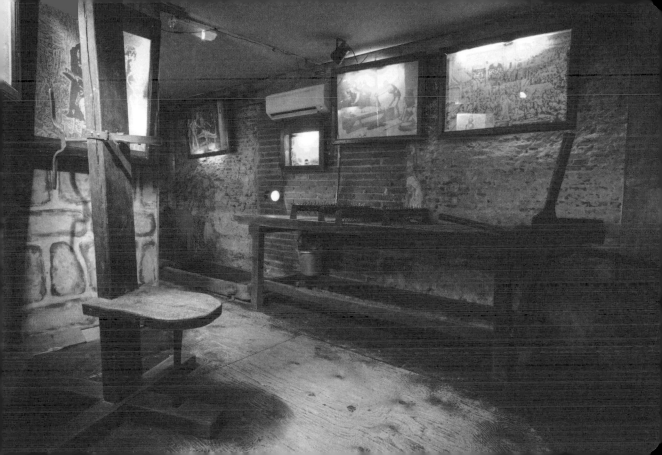

GALARVARVSVAGEN 14, DJURGARDEN,
STOCKHOLM, SWEDEN
WWW.VASAMUSEET.SE

Vasa Museum / Sweden

THE NAME OF THIS PLACE GIVES NOTHING AWAY.
The museum is eponymously titled for its sole exhibit, the magnificent Vasa warship. The Vasa is the only 17th-century warship preserved almost entirely in original condition and its story is one of maritime legend.

WE LOVE A GOOD LEGEND, TELL THE TALE.
Built to be a symbol of strength for the Swedish king, Gustavus Adolphus, the Vasa was richly decorated and endowed with enormous bronze cannons, designed to make her the most commanding ship on the sea and an intimidating weapon in Sweden's war with Poland-Lithuania. Unfortunately for Gustav, his military aspirations outstripped his engineering capabilities and the ship sunk on her maiden voyage, overbalanced by the weighty cannons.

BUT THE STORY DOESN'T END THERE?
It very nearly did. After the valuable cannons were recovered from the wreck in the late 17th century, the ship lay undisturbed for more than 330 years. Then, in the 1970s, she was rediscovered in a busy shipping channel. So began the long process of salvaging and restoring the mighty warship.

SO WHAT WE SEE TODAY IS THE REAL THING?
Impressively, yes. Over 95% of the display is original. The three masts displayed outside show the ship's original height.

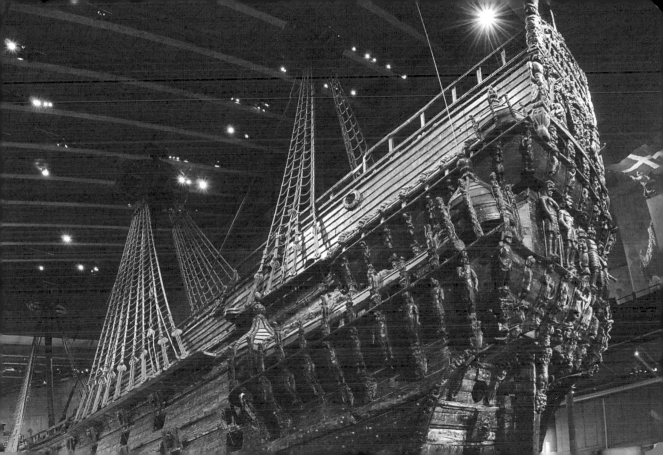

HUK AVENY 35, OSLO, NORWAY

WWW.KHM.UIO.NO

Viking Ship Museum / Norway

A LITTLE PILLAGING, BERSERKER STYLE?
Vikings are cool. Cool boats, cool beards, cool feasts, a love of the great outdoors and travelling the world. They're like the hipsters of the Dark Ages.

YUH, COOL.
This museum is about the ships, no bones about it. They're beautiful and have great stories buried in their remains.

DO TELL.
The 'Oseberg Ship' is the jewel here. She was excavated from a burial mound in the early 1900s and restored to something of her original glory – 90% of what you see is the original ship. But there are other ships here too, as well as various tools and artefacts from the era to boot.

HOW DOES A VIKING SHIP GET BURIED?
The Oseberg ship became a burial ship – she was dragged ashore to become the resting place for two women 1200 years ago. This was pretty common back in the good old days. The bonus here is that entry to the Viking Ship Museum gets you entry to the Historical Museum which, among other things, displays the only complete Viking helmet to have been found. I told you they were cool!

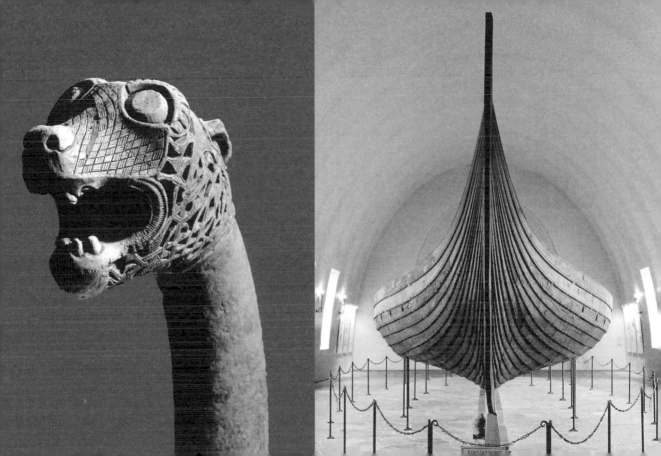

Whitney Plantation / USA

A MUSEUM DEDICATED TO SLAVERY? THIS SHOULD MAKE FOR A SOBERING EXPERIENCE.

Not every museum tells a happy story. This is one such place. However despite the serious subject matter this is a fascinating, illuminating and historically significant memorial to the practice of slavery in America.

TELL US MORE ABOUT HOW AND WHY THIS MUSEUM CAME TO BE.

The museum began as a passion project of trial attorney John Cummings and his director of research, Ibrahima Seck. Cummings spent 16 years and close to US$8 million of his personal fortune to build the museum and educate visitors on the realities of slavery and its impact on modern America.

HOW DOES THIS DESIRE TRANSLATE TO A MUSEUM EXHIBIT?

This is an open-air museum, a 1700-acre property designed to allow visitors to experience the world of an 1830s sugar plantation through the eyes of the enslaved people who lived and worked here. There are restored plantation buildings, including the French-Creole main house, slave quarters and cages. One of the most moving exhibits is the recorded stories of residents of the plantation.

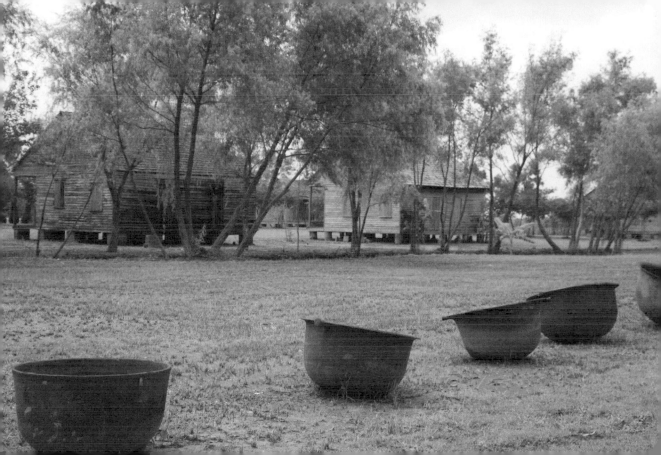

The world around us // Natural history museums

UNIVERSITY EMBANKMENT 3, ST
PETERSBURG, RUSSIA
WWW.KUNSTKAMERA.RU

Kunstkamera / Russia

SO I HEAR THIS IS A MUSEUM OF ETHNOLOGY AND ANTHROPOLOGY?

Umm, sure, kind of. Though the academics among us could argue that this museum may not really qualify as a hotbed of cultural investigation.

WHAT DOES THAT MEAN?

Peter the Great founded the museum in 1714 in order to show that malformations of the human body were not the result of witchery or evil magic, but were caused by damage incurred during pregnancy or by certain 'beliefs' of the mother during pregnancy (enlightened, no?).

SO WHAT EXACTLY ARE WE GOING TO SEE?

Think formaldehyde and jars. Two headed foeti and other such fascinating, if unsettling, artefacts. Memo: not one for small children or the parent-to-be.

SOUNDS GROSS.

To be fair, there's more here than babies in jars. There are dummies dressed in various ethnic European costumes and utensils utilised by these same cultures, there are even some medical instruments that... oh who are we kidding, it's really all about the curiosities. It's decidedly unnerving. You'll love it.

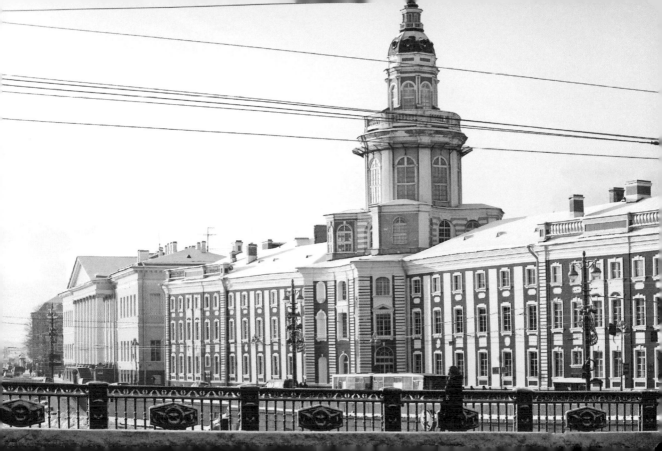

Messner Mountain Museum / Italy

IS THIS A MUSEUM THAT COUNTS AN ENTIRE MOUNTAIN AS AN EXHIBIT?

If you're picturing some kind of magic trick where mountains are turned into molehills in order to fit inside a museum space then we're sorry to disappoint on the miracle front.

WELL HOW IS THIS GOING TO WORK THEN?

The Messner Museum is the brainchild and lifetime passion of mountaineer and climber Reinhold Messner. He turned his obsession with mountains into a museum project that aims to be an education on the geology of mountains and glaciers, an exploration of the myths and legends of particular mountains and the history of mountaineering and rock climbing, and last, but not least, a study of the various cultural groups that call mountains home.

A MOUNTAINOUS UNDERTAKING.

So much so that the museum is spread over six locations, with a particular focus at each: Firmian (man's relationship with mountains); Corones (the discipline of mountaineering); Juval (the mystical and religious significance of mountains); Dolomites (geology); Ortles (glaciers and climbing on ice); and finally Ripa (the culture, religion and tourism of mountain people from around the world).

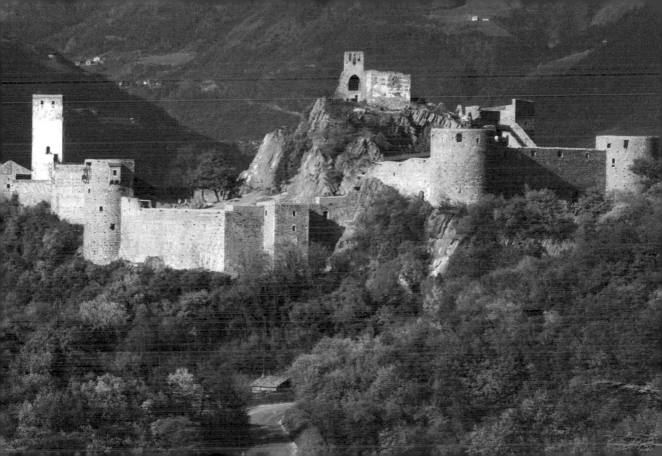

JLN TUN ABANG HAJI OPENG,
KUCHING, SARAWAK, MALAYSIA
WWW.MUSEUM.SARAWAK.GOV.MY

Sarawak State Museum / Malaysia

NOT ANOTHER BORING STATE MUSEUM!
If you have memories of primary school excursions to dinky cultural museums with a few dusty exhibits then you're about to be pleasantly surprised.

I GUESS BORNEO HAS ALWAYS HAD A WILD AND MYSTERIOUS EDGE.
This is a world-class ethnological and archaeological museum and gives visitors an illuminating insight into the natural history of the Malay archipelago. We're talking a vast assortment of taxidermied creatures including orangutans, birds and wild cats, exhibitions of tribal tattooing, textiles, magnificent iron works, and ceremonial masks from various tribal groups, including the renowned Dayak people.

ARE THE DAYAK THE TRIBAL GROUP WHO PRACTISED HEADHUNTING?
The very same. The museum has a replica longhouse of the Dayak people which is adorned in traditional style with actual human skulls. The Dayak believed that the heads would bring good fortune and prosperity to the community and they adhered to certain rituals and rules, including food offerings, in order to placate the spirits of the skulls; some of these rules and rituals are still followed today.

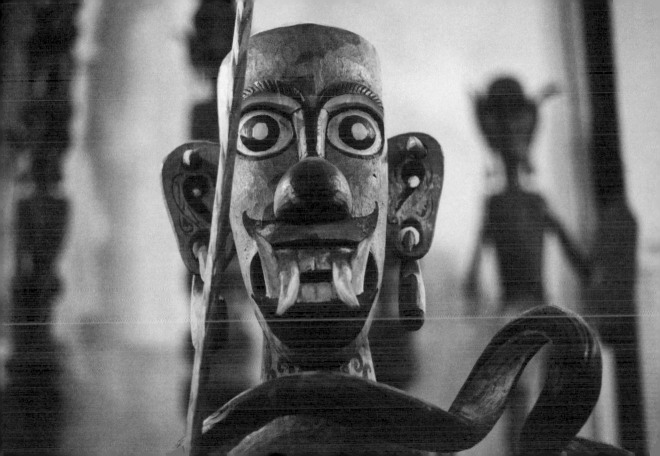

1000 JEFFERSON DR, SW,
WASHINGTON, DC, USA
WWW.SI.EDU

Smithsonian Institution / USA

I'VE HEARD ABOUT THIS PLACE – IT'S HUGE.

Ah ha, in true US style this complex is ginormous; in fact it's the largest museum complex in the world. Made up of 19 museums and galleries and a National Zoological Park.

IT SOUNDS LIKE QUITE A TIME COMMITMENT...

A visit requires at least three days of your time and some military-grade organisational skills. The information centre can help you plan but it's generally acknowledged that the museums of Natural History, the American Indian, American History, and Air and Space are not to be missed.

HIGHLIGHTS PLEASE.

OK, get ready. Here's what's hot at the Natural History Museum: the 'Hope Diamond', the 8-tonne model of an African elephant, the Neanderthal man reconstructions, the mummies, and the live coral reef. At the American Indian Museum don't miss the Navajo paintings and the photographs by Leuman M Waugh. Get a taste of American History by seeing Edison's light bulb, George Washington's uniform and Dorothy's red slippers. Finish your whistle-stop tour at the Air and Space museum where you'll see planes piloted by both the Wright brothers and Amelia Earhart, an Apollo command module, and a model of *Star Trek*'s USS *Enterprise*.

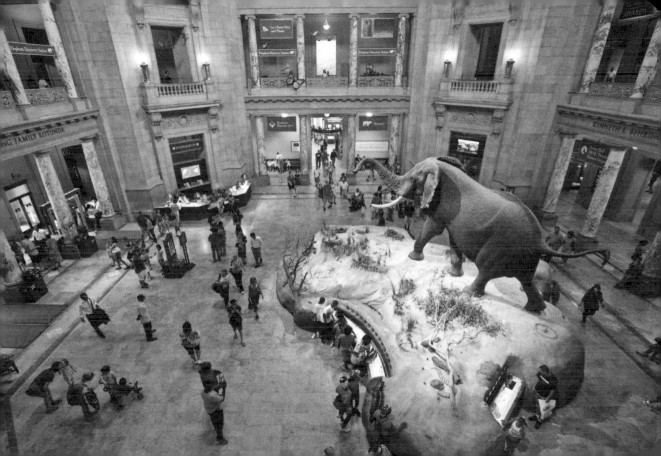

Human creativity //
Art & culture museums

579 ENDICOTT ST N, LACONIA,
NEW HAMPSHIRE, USA
WWW.CLASSICARCADEMUSEUM.ORG

American Classic Arcade Museum / USA

HELLO? HELLO?
Beep...beep...boop...BOOM! Sorry, it's the games. They're so addictive.

SO WE'RE HERE TO PLAY?
There are more arcade games here than anywhere else in the world, and it's not a stay-behind-the-rope-please museum. It's a go-for-a-high-score kind of place. Can I go now?

WHAT GAMES DO THEY HAVE?
SO. MANY. So many, it's hard to talk about it. Pac-Man is calling me, Tetris, Star Wars, Frogger, Galaga, Pole Position, Donkey Kong, the list goes on and on and on. There are around 300 arcade and pinball machines in the collection.

SOUNDS LIKE A GIANT ARCADE, NOT A MUSEUM.
In some ways it is, but it's the arcade of your life history, every pimply period of your gaming life covered. Play every game and relive all those high moments of teenage fame.

YOU CAN GO BACK TO THE GAMES NOW.
Thank you. I challenge you to a game of Defender. And then we can move to the ultra-rare games in the special collection. Strap yourself in.

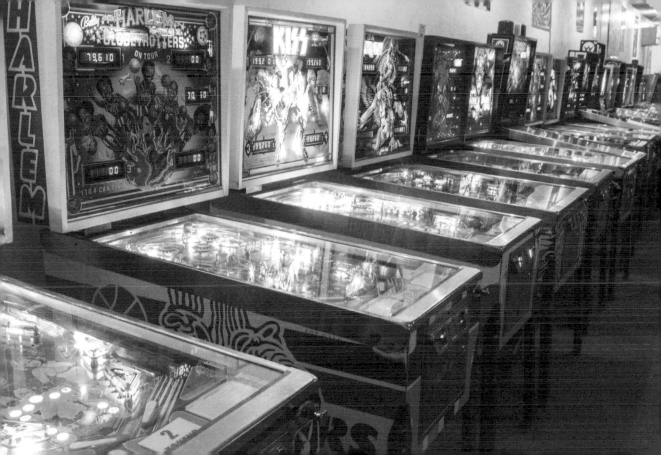

BREWERS' HOUSE, GRAND PLACE
10, BRUSSELS, BELGIUM
WWW.BELGIANBREWERS.BE

Belgian Brewers Museum / Belgium

I'M SO HOPPY RIGHT NOW.
Don't you mean 'happy?' Oh, I see what you did there.
Very good.

THANK YOU.
It's great that you're not just along for the ride. Now, beer. Yes,
if beer is your thing, this is the museum for you. There aren't
many things more Belgian than beer, and this museum, housed
in the basement of Brewers House, gives a bit of history, a bit
of how-beer-is-made action, and...

TELL ME I GET TO TASTE BEER.
Give me a second! Where was I...and...yes, a café where you
can sample some local brews.

IT IS A MUSEUM THOUGH? NOT A BAR?
It's a fine line here – you could well spend more time
enjoying the beer than exploring exhibits. One drink is
included in the entry fee. Consider it a living museum, and
become part of the exhibition yourself. We'll look out for you
at the bar.

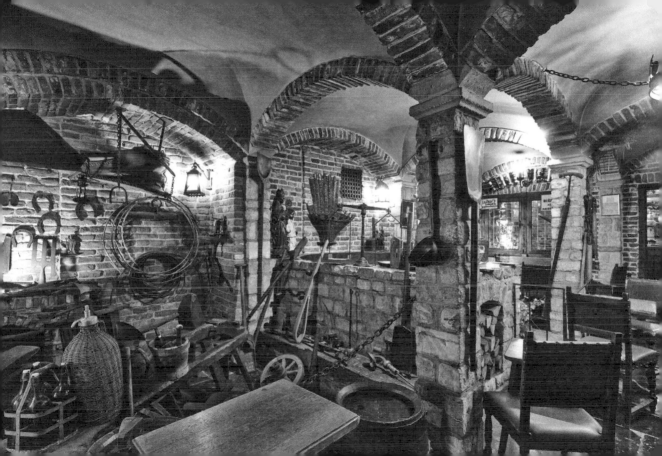

Burlesque Hall of Fame / USA

ONLY IN VEGAS.
Actually, this museum used to be on the site of an abandoned goat farm in California, but we're thinking those bucolic surrounds didn't sit well with the museum's subject matter. So it swiftly moved to the bright lights of America's sin city.

THIS DOESN'T SOUND LIKE ONE FOR THE WHOLE FAMILY.
Despite the exotic connotations, the once-private collection of retired dancer Jennie Lee is a fascinating historical account of the evolution of burlesque in America. Covering the early 19th century to the present day, the collection is a celebration of burlesque as art – the comedy, dance, music and costume – more than it is a glimpse into erotica.

UH HUH, I'VE COME TO VEGAS TO 'STUDY' BURLESQUE... I'M NOT INHALING, I'M JUST READING IT FOR THE ARTICLES.
Sure... If you want to see burlesque in action you can head to any one of the numerous casinos on Las Vegas' iconic Strip or beyond. But if you want an insight into its famed costumes, jewellery, choreography, pioneering performers and much more, then you're in the right place here.

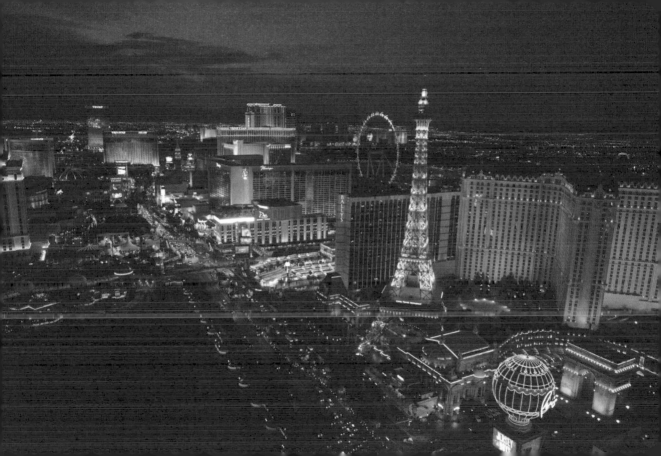

Coffee Museum / Brazil

LEARNING ABOUT COFFEE IN BRAZIL SOMEHOW FEELS RIGHT.

It's got to be the spiritual home of coffee, right? Sure, coffee originated in Ethiopia, but Brazil is by far the world's biggest producer of the much-loved little pep-up bean: a third of all coffee is cultivated and produced here.

WHO KNEW? SO WHAT DOES A BRAZILIAN COFFEE MUSEUM DO, EXACTLY?

The museum is housed in the former coffee stock-exchange building – coffee was Brazil's primary source of income for much of the 20th century and Santos was where the traders would come to do their coffee business, setting the price of the precious, wonderful bean. The building is striking in its own right, with the trading room's stained-glass ceiling, the 37-metre clock tower and the art throughout.

WHAT'S THE ANGLE?

Bottom line: the museum explores Brazil's coffee history and industry through permanent and temporary exhibits. You can even buy a coffee at the cafe and enjoy the brew outside as you check out the coffee-bean patterned pavement.

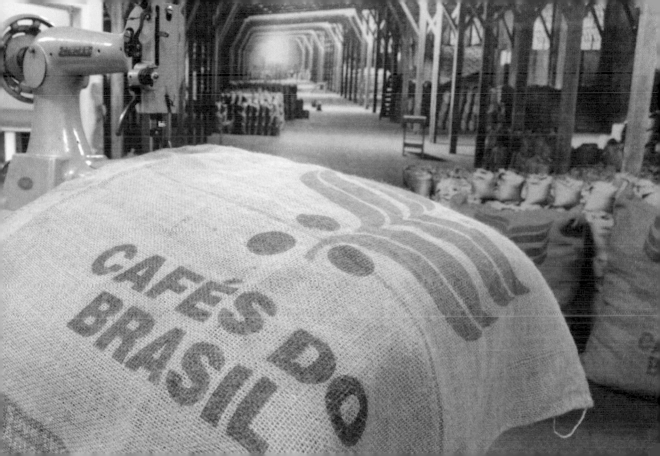

99/9 MOO 1, BANG MUANG MAI,
SAMUT PRAKAN, THAILAND
WWW.ERAWAN-MUSEUM.COM

Erawan Museum / Thailand

FROM THE OUTSIDE THIS PLACE LOOKS LIKE A GIANT ELEPHANT.

It is. The museum is housed inside the five-storey, 250-tonne sculpture of a three-headed elephant. An enormous homage to Erawan, the revered Hindu elephant god. Cool, hey?

I'VE OFTEN WONDERED WHAT I'D FIND INSIDE AN ELEPHANT.

Thai sculptures of mythical dragons and fairies pepper the interior, there are ancient ceramics and gold statues towering over the ground floor, and all the exhibits are beautifully cast in the coloured light of the stunning stained-glass ceiling.

IT SOUNDS TOTALLY TRIPPY.

It's certainly an eclectic and magical mix of artefacts. The collection is the heart's desire of eccentric Bangkok businessman, Lek Viriyabhun, who unfortunately passed away before the museum opened in 2004. To get the full effect of Lek's creative vision, clamber up the steep spiral staircase to get a close-up view of the multicoloured glass roof and a bird's-eye look at the exhibits below.

MY SENSES ARE OVERWHELMED.

When it's time for your psychedelic trip to end, head outside to take some deep breaths in the tropical flower gardens.

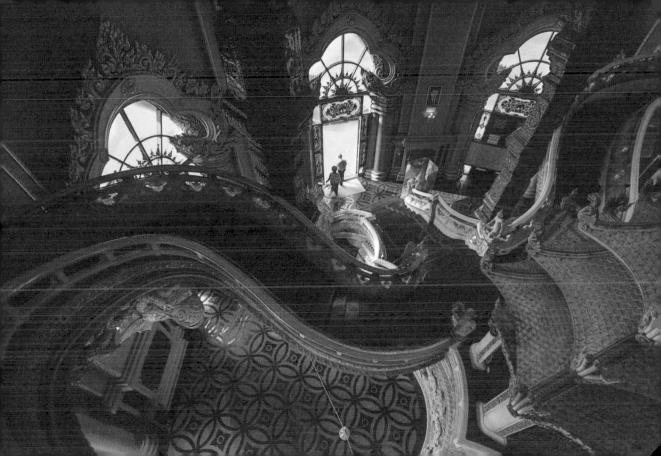

1-1-83 SIMORENJAKU,
MITAKA-SHI, TOKYO, JAPAN
WWW.GHIBLI-MUSEUM.JP

Ghibli Museum / Japan

IS THIS OUR OPPORTUNITY TO MEET THE DELIGHTFUL TOTORO?

It is. The gorgeous animated creations from the inspired master of Japanese anime, Hayao Miyazaki, are all here, from *Princess Mononoke* and the cast of *Spirited Away* to *My Neighbor Totoro* (you'll see him peering enigmatically through the glass at the entrance).

IT SOUNDS LIKE A MUST-SEE FOR THE KIDS.

Kids will love the huge, furry bus, which they can clamber inside, and they'll marvel at the giant robot propped up on the roof, but the museum is not just for children; it caters to anime fans of all ages with some beautiful, detailed artist sketches and animation cels on display. The in-house theatre shows a short film, made especially for the museum, that can't be seen anywhere else.

A MAGICAL EXPERIENCE.

With the crowds to prove it. Buy tickets well in advance as it is always busy. If you find you need a break from the crowds of fans inside, take a leisurely stroll through Inokashira Park, the lush garden in which the museum is located.

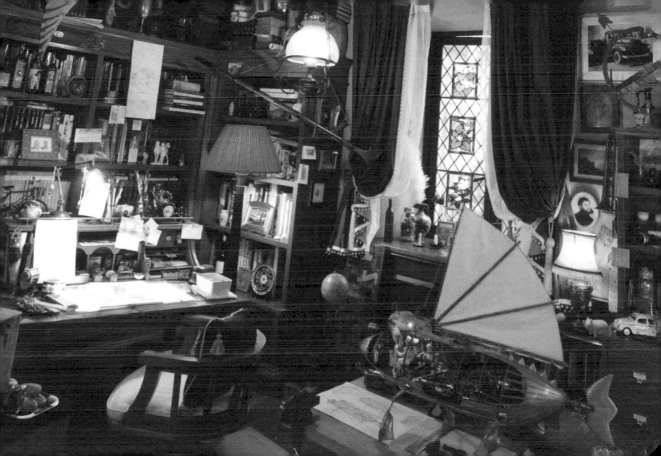

800 W OLYMPIC BLVD, LOS
ANGELES, CALIFORNIA, USA
WWW.GRAMMYMUSEUM.ORG

Grammy Museum / USA

ROCK MUSIC AWARDS?

Rock, pop, R&B, hip hop...here there's no stone left unturned. There are 160 genres of music to explore right from the get-go.

THERE CAN'T BE THAT MANY GENRES!

Well we can't list them all here, but the Grammy Museum is definitely the place to be convinced otherwise. It's a powerhouse museum, thoughtful, creative and engaging. It'll reignite your love of music and your admiration for those who make it. Go, explore!

HOW DO I EXPLORE IN A MUSIC MUSEUM?

Seriously, if you have an interest in music, you're going to be blown away by this place. Creating music, recording music, the stars themselves, the instruments they play...you can see, experience, hear and touch your way through decades of popular culture as revealed through music.

I'VE ALWAYS WANTED TO BE A ROCK STAR.

The inspiration is here. There are special exhibits as well, often focusing on particular artists, so you could visit a few times and experience something different on each occasion.

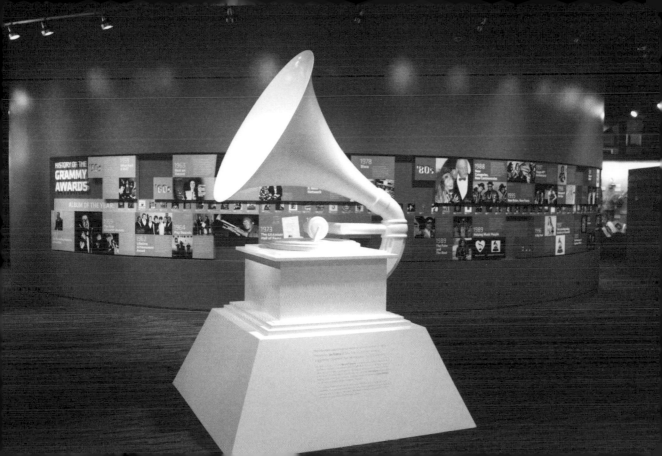

RESIDENZSCHLOSS, TASCHENBERG
2, DRESDEN, GERMANY
WWW.SKD.MUSEUM

The Green Vault / Germany

GREEN VAULT...A SAFE FULL OF MONEY?

Definitely, though not the folding kind. Inside is Europe's largest collection of royal treasures. What was once the private curio collection of Augustus the Strong, ruler of Saxony from 1694 to 1733, is now a trove open to the public.

SO IT'S A ROYAL TOY COLLECTION.

There's not really a name for what this collection comprises. Here's a sample of the royal weirdness you're able to witness: a miniature gold royal court with teeny tiny court dolls, crafted in minute detail; a solid gold drinking bowl believed to have belonged to Ivan the Terrible; carved cabinetry that pours its own wine; and the pièce de résistance, the spectacular 'Dresden Green', an iridescent green diamond from India.

HOW DID THIS STUFF SURVIVE THE BOMBING IN WWII?

Some of it didn't. In fact, the 'Green' in the museum's name comes from the painted malachite columns and green velvet wall coverings from the original vault that was part of the Dresden Castle – the castle was completely destroyed during the bombing. Luckily many of the vault's treasures were removed from the castle at the start of the war.

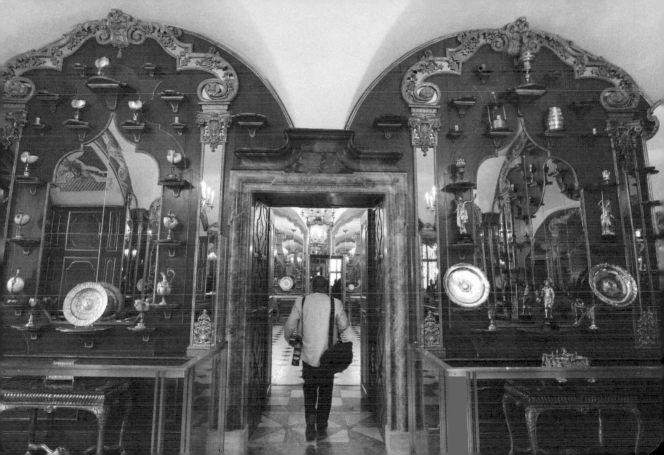

42 HIGH ST, ROYAL MILE,
EDINBURGH, SCOTLAND, UK
WWW.EDINBURGHMUSEUMS.ORG.UK

Museum of Childhood / UK

IS THIS GOING TO BE LIKE GOING THROUGH SOMEONE ELSE'S BABY PHOTOS?

There is kind of an anthropological element to this museum – showing how children have grown up from the 18th to the 21st century – and it was the first museum worldwide to specialise in the history of childhood. Though really it's all about the toys, toys and... toys.

SO BARBIES AND LEGO IN GLASS CASES?

There are examples of playthings from the 'good old days' that would make kids of today roll their eyes in boredom – marble sets and wooden Yo-Yos. The collection covers the 50s, 60s, 70, 80s and 90s with favourites like Star Wars paraphernalia , Teletubbies, Toy Story figurines and Nintendo. A fun trip down memory lane for the kid in us all. There's also a huge collection of books, comics and magazines and displays of kid's clothes through the ages.

IS IT ALL 'LOOK, DON'T TOUCH'?

Thankfully the curators of the museum understand that putting children in a room full of toys they can't touch is a recipe for disaster, so there are hands-on activities like a puppet theatre and dress-up area where your tykes can practise their best street urchin impressions.

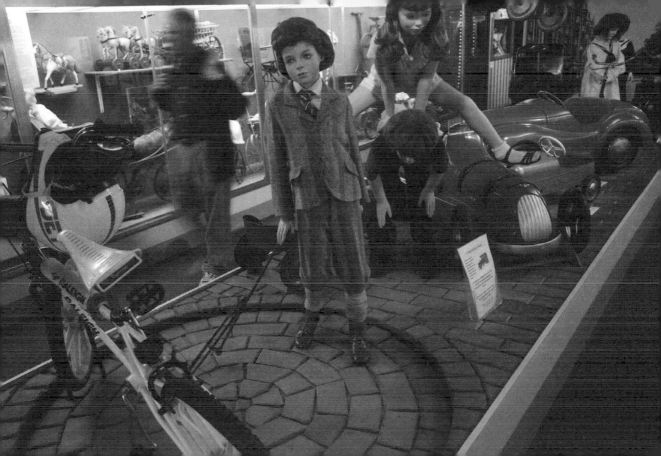

Musical Instruments Museum / USA

THERE ARE A FEW OF THESE MUSICAL INSTRUMENT MUSEUMS AROUND THE WORLD. WHY SHOULD I VISIT THIS ONE?

This Phoenix-based museum stakes its claim as one of the best by showcasing musical instruments from every country in the world. There are more than 15,000 instruments on display throughout five geographically arranged galleries.

WORLD MUSIC AT ITS BEST.

From an antique European charter horn to mechanical zithers to the iconic modern-day Fender guitar and everything in between.

I RECOGNISE THE FENDER.

There's also an entire gallery devoted to world-famous artists. You can see instruments played by Elvis, John Lennon, Johnny Cash, cellist Pablo Casals and Taylor Swift.

IF THERE WAS EVER ANY DOUBT THAT MUSIC WAS A UNIVERSAL LANGUAGE THIS PLACE PUTS THAT UNCERTAINTY TO BED.

Visitors are given the opportunity to speak the language in the 'Experience' gallery: try your hand at playing guitars, Southeast Asian tribal drums, Japanese gongs – and even the quirky, electronic theremin.

Soumaya Museum / Mexico

IS THIS THE SILVER-PLATED BEHEMOTH BUILT BY THE MEXICAN BILLIONAIRE?
One and the same. The folly of one of the world's richest men, Carlos Slim, the Soumaya is named after Carlos' late wife and has some stand-out exhibits housed in an enormous, hourglass-shaped, shining edifice.

THIS SOUNDS LIKE IT'S ONE HELL OF A PRIVATE COLLECTION.
Money might not buy you love but it can buy just about everything else. Slim's collection numbers close to 70,000 pieces, at an estimated worth of more than US$700 million.

WHAT KIND OF PIECES CAN WE EXPECT TO SEE?
There are works by famous Modernist and Impressionist masters like Picasso, Dalí, Renoir and Monet, as well as the world's largest assortment of sculptures by Rodin, over 380 pieces in fact.

A SLICE OF EUROPE IN THE HEART OF MEXICO.
While works by the European masters garner a great deal of attention, there's actually a large selection of Mexican artworks – everything from musical instruments, furniture, photography, fashion, and decorative and graphic arts. It's one of the most eclectic collections that money could buy.

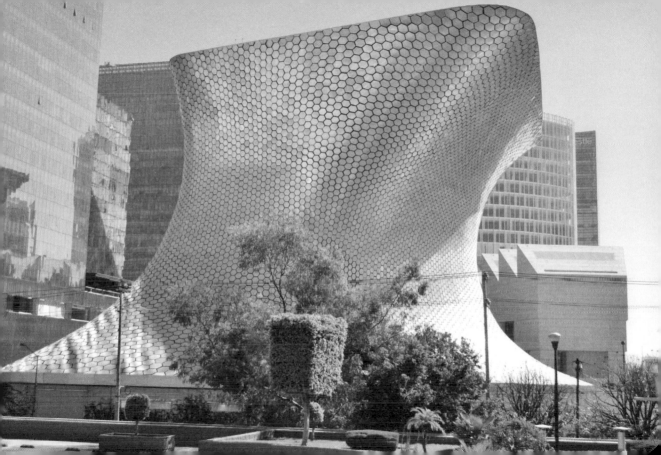

Vodka Museum / Russia

VODKA 'MUSEUM'?
No really, no inverted commas needed: every effort is made to ensure an informative, sober visit.

WELL I GUESS IF THERE'S A NATION THAT KNOWS ITS VODKA IT'LL BE RUSSIA.
Too true. The museum focuses on the inextricable links between the country's favourite drink and the Russian state.

I'M THINKING OF BORIS YELTSIN SWAYING ON THE INTERNATIONAL STAGE NEXT TO FORMER PRESIDENT BILL CLINTON.
Well, yes, Russia's presidents have been known to like a tipple and Boris' boozy moment proved the liquor's ubiquity.

DRUNK DIGNITARIES ASIDE, WHAT WILL WE SEE?
The museum delves into the history, culture and traditions surrounding the consumption of vodka, from 12th-century 'bread wine' to the modern day behemoth that is the vodka industry. There are displays of bottles, old ad campaigns and and dioramas on the development of this strong liquor.

CUT TO THE CHASE, DO I GET TO HAVE A TASTE?
Yes! There's a separate tasting room for sampling different vodka varieties, accompanied by traditional Russian snacks.

Things that go //
Science & technology museums

7 W MONROE ST, NEW BREMEN,
OHIO, USA
WWW.BICYCLEMUSEUM.COM

Bicycle Museum of America / USA

THIS IS AN UNLIKELY ONE.
Sometimes it's the unexpected places that deliver the goods. This museum combines great exhibits and interested, interesting staff – before you know it, you'll be a spoke spotter yourself.

SPOKE SPOTTER? YOU MADE THAT UP.
So sue me. Anyway, the museum has a couple of hundred years of bicycle history covered. There are 300 bicycles on display and many, many more on rotation.

SEEN ONE, SEEM 'EM ALL, SURELY?
Bicycles have come a long way since their mysterious first appearance (there's no verified claim to 'inventor of the bicycle'). From the awkward big front wheel of penny farthings to the tough (tuff?) stability of a BMX, you won't believe the designs that have pedalled out of showrooms over the years. And you can see many of them here. The curators reckon that with about 1000 bikes in the collection, you'll probably see your own first machine here; prepare for a little nostalgia as you recall that first tumble off your bike...

TUCKER ST, KIMBERLEY,
SOUTH AFRICA
WWW.THEBIGHOLE.CO.ZA

Big Hole & Open Mine Museum / South Africa

IS THIS JUST A BIG HOLE IN THE GROUND?
Well, yes and no. The Big Hole and Open Mine museum does claim to sport the largest hand-dug excavation in the world, and with a perimeter of 1.6km and a depth of over 240m it is a pretty impressive big hole in the ground. Still, it's why it was dug that piques the interest of most visitors.

GO ON.
In 1866 Erasmus Jacobs found a white pebble on the banks of the Orange River, near Hopetown. It turned out to be a 21-carat diamond. Diamond fever ensued and the area turned into a frontier town for thousands of fortune hunters.

IS IT STILL A FUNCTIONING MINE?
No, the Big Hole closed in 1914, more than 40 years after digging began – but not before it yielded three tonnes of diamonds. Yes, you read that right – three tonnes of diamonds! Eureka indeed.

CAN I GET A GOOD LOOK INTO THE MINE?
Yes, this is an open-air museum with multiple viewing platforms which give you a bird's-eye view into the pit. There's also a collection of original houses, shops and workplaces from the rush period and a simulated diamond dig.

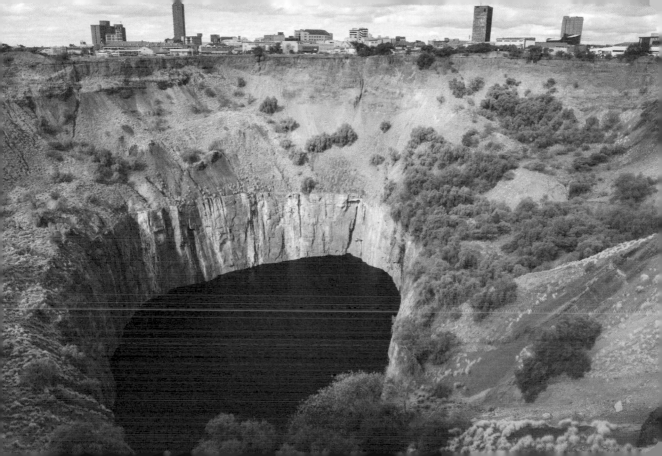

PIER 15, THE EMBARCADERO,
SAN FRANCISCO, USA
WWW.EXPLORATORIUM.EDU

Exploratorium / USA

ARE WE OFF ON A MAGICAL MYSTERY TOUR?
Strap yourself in, you most certainly are. The stated mission of the Exploratorium is to 'change the way the world learns'. It's a funhouse full of experiential science experiments; an immersive journey into the world of physics, human behaviour, and living systems.

WHAT DOES THAT ALL MEAN?
The museum, originally set up by Frank Oppenheimer (younger brother of Robert Oppenheimer, of atomic-bomb fame), is designed to encourage informal learning by allowing direct participation in the exhibits. Since the museum opened, there have been over 1000 participatory displays – 600 of which are open to the public at any one time.

SO WHAT CAN WE GET OUR HANDS ON?
Tackle the Tactile Dome – a pitch-black chamber that asks you to crawl, slide and bump your way through using only your sense of touch. Or explore the Monochromatic Room – a colourless world lit like an old sepia photograph. In the Tinkering Studio you can do things like make clothing out of old plastic, take apart your favourite toy, build digital jewellery or make electrical circuits on flat paper. Endless entertainment that just happens to make you smarter.

I PLACE DU TROCADÉRO ET DU II
NOVEMBRE, 16E, PARIS, FRANCE
WWW.MUSEE-MARINE.FR

National Maritime Museum / France

AHOY SAILORS.

Naval buffs will love this maritime museum dedicated to all things nautical, but it's not just for the seafarers among us; this fascinating collection will appeal to landlubbers also.

I AM ONE OF THOSE – WHAT SIREN-SONG IS GOING TO CALL ME THERE?

Who can resist the lure of sunken treasures? The main gallery houses several romantic figureheads rescued from sunken shipwrecks. Check out the enormous Napoleon, decked out as a Roman emperor, which was recovered from a ship sunk in 1846; and a giant Henri IV from a Crimean War wreck, sunk in 1854. There's also a clunky metal diving suit from 1882 and compasses, sextants, telescopes and paintings.

AND BOATS?

It's an eye-opening journey from 17th-century ships to today's sophisticated vessels. When you see the intricate cross-section model of the gargantuan aircraft carrier or the detailed miniature replica of a modern-day warship you get an insight into the remarkable advances in maritime development over the last few hundred years.

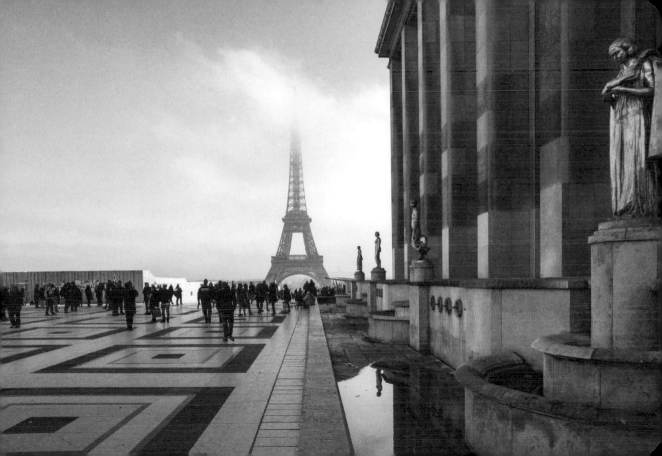

National Rail Museum / UK

TRAINSPOTTING!

You know it. What would a book about collectors be without some hard-core train action? And at this locomotive wonderland, there is no shortage of train devotees.

IF I COULD ONLY SPOT ONE TRAIN THERE, WHAT WOULD IT BE?

There's the 'Chinese Locomotive', the largest train in the collection. And you can also see the only Japanese bullet train to exist outside of Japan. Practically everything about trains – their development, impact, technology – is on show.

YOU SOUND LIKE YOU MIGHT BE A TRAINSPOTTER.

This museum could turn you for sure. There's even a lock of Robert Stephenson's hair. He was from locomotive royalty, and built the Rocket in 1829, a train that set the pace for steam train construction through the 19th century.

IT'S TOO LATE FOR YOU. HMMM.

Yes, it might be. But just go. Join me. We can wander the railway lines together. Forever.

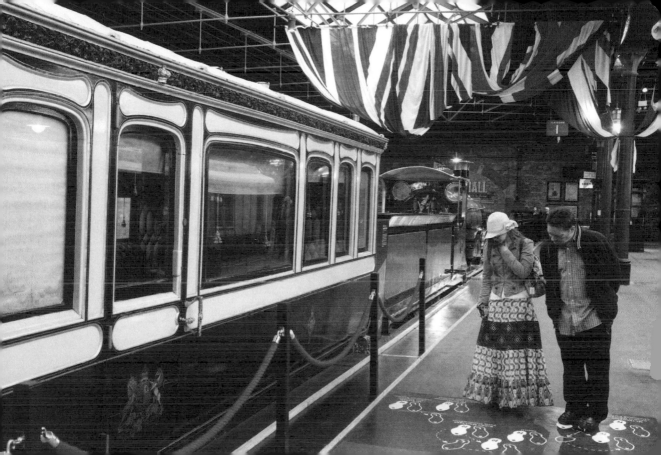

3198 STATE RTE 2001,
ALAMOGORDO, NEW MEXICO, USA
WWW.NMSPACEMUSEUM.ORG

New Mexico Museum of Space History / USA

TAKE ME TO THE MOON!
Rocket sleds, space shuttles, satellites, suits...in the middle of the New Mexico desert in a space-age (ie '70s!) building.

WHY AM I IN THE NEW MEXICO DESERT?
This region was home to a significant amount of development work for the space program. And, you know, Roswell is just 100 miles away: there's heritage here.

INTERESTING!
Did you know Ham, the astrochimp, first ape in space, is buried here?

I DID NOT. STICKY ENDING?
He lived out his retirement in a zoo in Washington – nothing adventurous. But he's an inspiring little guy.

BACK TO THE MUSEUM...
There are four floors of exhibits and they will keep you busy. There are exhibitions on what it's like to live and work in space; there's a section on the history and development of rocketry. And the Space Hall of Fame remembers and celebrates the crazy, er, brave men and women who have dedicated their lives to exploring space. It's a blast!

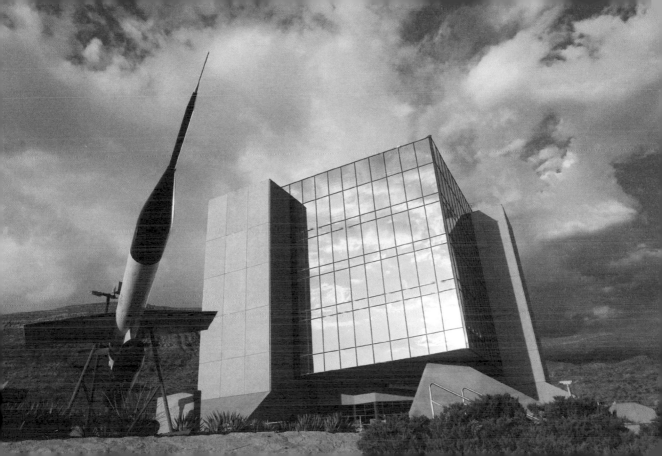

278 SPRING ST, NEW YORK
CITY, USA
WWW.NYCFIREMUSEUM.ORG

New York City Fire Museum / USA

FIRE!
Not a word to throw around willy-nilly.

I COULDN'T RESIST. WHAT'S THE DEAL HERE?
The deal is almost 400 years of fire-fighting history brought to life with equipment and stories. New York's big-city nature was there from the start; many people and many buildings in a small space meant fires had catastrophic potential.

GOTTA LOVE A FIREFIGHTER.
For sure. This museum celebrates their bravery, most notably in its 9/11 memorial to the 343 who lost their lives that day.

It's also staffed by retired firefighters who can provide first-hand accounts of an NYC fireman's working life.

WHAT ELSE IS THERE?
Fire engines! Hand-pumper engines, horse-drawn carriages, motorised – you name it, they got it! Plus all the tools of the trade – tell me you're not keen to see the Jaws of Life in action.

AS LONG AS I DON'T ACTUALLY NEED THEM TO SURVIVE, SURE.
I hear you. That's another thing, speaking of your well-being: the museum also aims to educate its visitors on fire prevention.

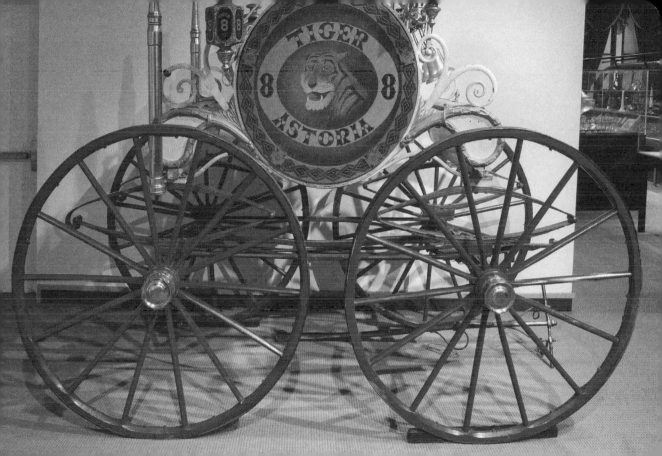

SOUTHEY WORKS, MAIN ST,
KESWICK, CUMBRIA, UK
WWW.PENCILMUSEUM.CO.UK

Pencil Museum / UK

HOW MUCH IS THERE TO REALLY KNOW ABOUT PENCILS?

I'll give it to you straight: it's difficult to come away from the pencil museum without forming a lifelong fascination and love for this simple little writing tool. Be warned.

I DON'T EVEN WRITE BY HAND ANYMORE.

There's a definite family vibe to this museum: kids still love pencils. And this museum has more pencils than you could poke a stick at. So put your device away for a moment and put pencil to paper. It's refreshing.

CAN I COLOUR IN?

After you've learned about the history of pencil making in the area, seen how a pencil was made, how it's produced today, generally bonded with the pencil and become one with it, only then may you wield it.

REALLY?

Kidding! But it's a genuinely gripping tour through local history and the importance of pencil making here. It's coming up to 200 years since Keswick pencil production began. You'll be inspired for sure. It'll put the lead back in your pencil.

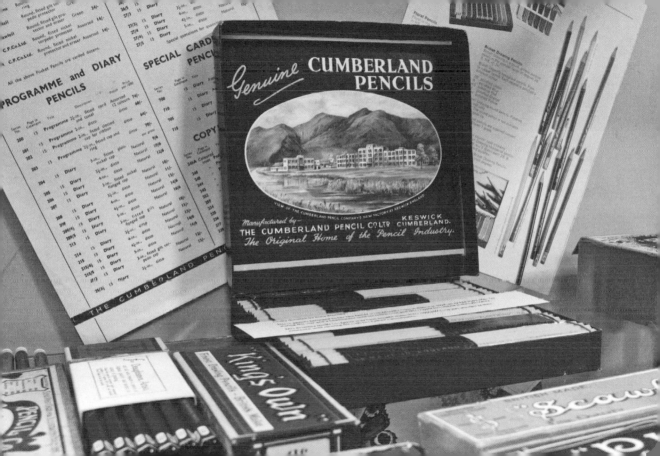

PORSCHEPLATZ I, STUTTGART,
GERMANY
WWW.PORSCHE.COM/MUSEUM/EN

Porsche Museum / Germany

A MIDLIFE-CRISIS MUSEUM? FINALLY!

Yeah, there are jokes to be made, for sure. But if you've ever been interested in cars, it's unlikely that a little Porsche fantasy hasn't preoccupied your waking dreams. And even if you're not a car nut, a Porsche is really the archetype for sports car, right?

I'M READY TO EMBRACE MY INNER 13-YEAR-OLD/47-YEAR-OLD.

Your mind will be set racing here. There are around 80 vehicles on display representing 100 years of Porsche history: Classic Porsche 356, Le Mans racers, recent models, plus trophies from famous Porsche motor racing victories.

BUT DO I GET TO DRIVE ANYTHING?

If you have the cash you can buy one. But otherwise, no, this is all about admiring and learning. You can even watch mechanics service the display machines in the workshop section of the museum.

WHAT WILL THE CHILDREN DO WHILE I'M PREOCCUPIED BY ALL THIS?

There's a kids museum rally course to keep them enthused. But seriously, kids will love this place. We always have!

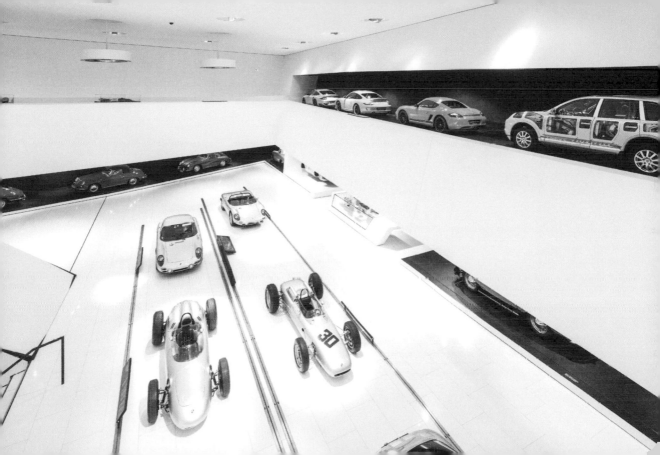

OPPOSITE 93 QUAI D'ORSAY,
PARIS, FRANCE
PHONE: +33 1 53 68 27 81

Sewer Museum / France

I'VE COME TO PARIS AND YOU'RE SENDING ME TO THE SEWERS?

We're not saying it's the only thing to do in the city of love, but Paris has one of the most complex sewer systems in the world and, well, you can't sit in cafes eating croissants all day long.

ALL RIGHT THEN, LET'S GET DOWN AND DIRTY.

Any ideas of smelly, dank and rat-infested tunnels are quickly dispelled when you descend into the large and surprisingly open network of sandstone subways. These tunnels carry rainwater, drain water from the streets, telecommunications cables and pneumatic tubes between post offices.

ERM, SO WHERE'S THE ACTUAL SEWERAGE?

The sanitary sewer pipes are all enclosed and separate. Breathe easy.

IT DOES ALL FEEL VERY CLEAN.

It's an engineer's and/or public planner's dream. An insight into the incredible behind-the-scenes design that goes into making a modern city run. Check out the huge basin that traps all the solid waste material from above and don't miss the gigantic wooden balls that were once sent rolling along the tunnels under the Seine in order to clear any blockages.

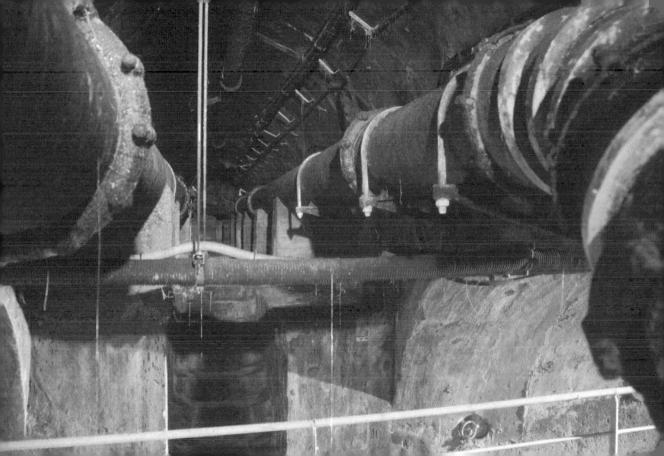

SULABH BHAWAN, MAHAVIR
ENCLAVE, PALAM DABRI MARG,
NEW DELHI, INDIA
WWW.SULABHTOILETMUSEUM.ORG

Sulabh International Museum of Toilets / India

AH, WHAT NOW? TOILETS?

The International Museum of Toilets grandly proclaims to 'explore the history of hygiene and sanitation'.

A SERIOUS STUDY INTO THE HUMBLE TOILET?

The seriously great thing about this museum is that it is run by a charity that works tirelessly to bring sanitation to India's poor and destitute. And there's some genuinely interesting toilet-related artefacts on display – from 2500 BC to present-day.

ALL RIGHT, GIVE ME A PORCELAIN THRONE HIGHLIGHT.

Funny you should mention the throne, the museum houses a replica of the toilet used by King Louis XIV. It's very... regal.

AND THE REST?

How about chamber pots from the 17th century? Or French toilets that were designed to be disguised or completely hidden from view? Check out the medieval women's toilets. Design has come a long way since the 'good old days'.

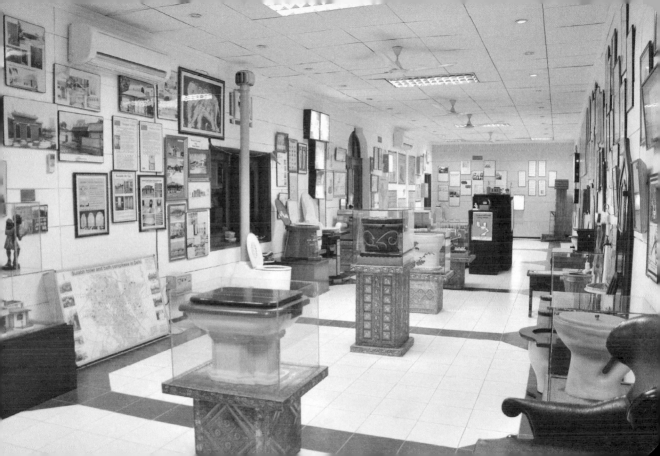

Peculiar passions //
Quirky museums

FIRIN SOKAK 24, AVANOS,
CAPPADOCIA, TURKEY
WWW.CHEZGALIP.COM
PHONE : +90 384 384 511 4240

Avanos Hair Museum / Turkey

A HAIR MUSEUM?

There's no denying that a cave in Cappadocia festooned with thousands of samples of women's hair nests firmly in the camp of quirky when it comes to museums.

'QUIRKY' IS THE POLITE WAY TO PUT IT.

Before the potential creepiness of the place gets the better of you, let us tell you the sweet story that goes behind the strange assortment. Word has it that the collection began when the lovelorn potter from the ceramics gallery attached to the museum was forced to bid farewell to a female friend.

To remember her by, he asked for a lock of her hair. As a tribute to his heartbreak, female visitors to the pottery also trimmed their locks and added them to his collection. The rest is hirsute history.

UM, OK, STILL PRETTY WEIRD.

Yeah, who are we kidding? It's totally bizarre. You're welcome to be a part of the weirdness (if you're a woman, of course) – the museum provides scissors, tape, pen and paper for you to cut your own contribution and attach it to the already super hairy walls of the cave.

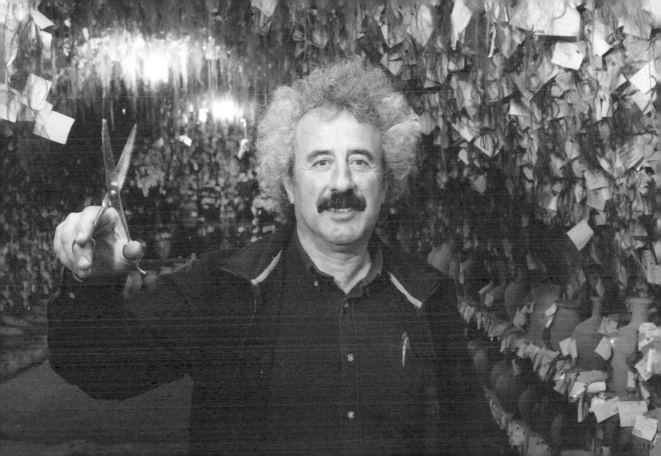

102 4TH ST, BARABOO,
WISCONSIN, USA
WWW.THECLOWNMUSEUM.COM

Clown Hall of Fame & Research Centre / USA

OOOH CLOWNS ARE SCARY, MAN!

Sure, it's safe to say that this museum is certainly not for those who suffer from coulrophobia (fear of clowns).

SO I'M IMMUNE... WHAT'S IN STORE?

The Hall of Fame celebrates the art of clowning and all the antics and historical significance that go with it. There are performances from actual clowns during the scheduled tours.

HILARITY ENSUES, NO?

This clowning stuff is serious business. The museum documents clowns through the ages, from the earliest circus performers to representations of clowns in modern TV and cinema. There's particular mention of famous and long-standing members of the clowning elite – 25 years' experience in the industry is needed in order to even be considered as an inductee into the Clown Hall of Fame.

WITH ALL THIS EXPERIENCE IS THERE ANYONE I WOULD RECOGNISE?

You remember Nat Wills, the Happy Tramp? Or Bruce Johnson, the Juggling Clown? Perhaps not, but that won't matter; the scores of fantastic photos and detailed historical footage is endearing and entirely entertaining.

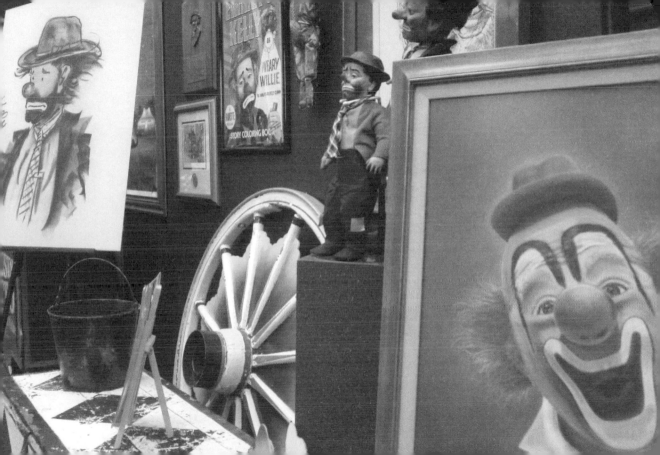

2-3-4 SHINKO, NAKA-KU,
YOKOHAMA, JAPAN
WWW.CUPNOODLES-MUSEUM.JP

Cupnoodles Museum / Japan

CUP NOODLES?

It may be difficult to believe that a museum dedicated to the humble cup noodle, or instant ramen as it's more commonly known in Japan, could be anything more than a glorified supermarket shelf, but this museum proves its worth.

SO IT'S NOT JUST OODLES OF NOODLES?

There is a room displaying 3000 packets of instant ramen, so yes, there are more noodles than you can poke a chopstick at, but there's more. The museum celebrates the life of the father of ramen, Momofuku Ando, and includes a replica of the shed in which Momofuku invented the first chicken ramen.

SOUNDS LIKE ONE FOR THE AFICIONADO.

Come on, we've all had our cup noodle phase.

ALL RIGHT, YOU GOT ME THERE. WHAT ELSE?

There's an animated movie detailing the history of ramen, an indoor cup noodle park where kids can interact with the ramen manufacturing process from the perspective of the noodle (really!), a factory where visitors can create their own totally original cup noodle package – from cup design to noodle ingredients – and last but not least, a noodles bazaar where you can sample the famous goods.

208 I ST S, TORRINGTON,
ALBERTA, CANADA
WWW.GOPHERHOLEMUSEUM.CA

Gopher Hole Museum / Canada

LET'S NOT BEAT AROUND THE BUSH – GOPHER HOLES?!

You never knew you needed to know, did you? But life will never be the same once you've seen the little guys in action.

ACTION?

Let's set the scene. The gophers aren't really gophers, they're Richardson's ground squirrels. And the holes aren't really holes, they're boxes containing dioramas. The action consists of 'gophers' in various states of dress-up. Gophers having a picnic? Gophers playing pool? Gophers running a gas station? Yep, yep and yep. And many more to boot.

THESE SOUND LIKE EXCEPTIONALLY WELL-TRAINED GOPHERS.

Um, right... about that – this is a taxidermist's paradise. The town of Torrington and its surrounding farms have a love-hate relationship with the little critters. They hate them alive and raiding their crops, they love them stuffed and playing like people for tourists.

THIS IS SOUNDING A LITTLE WEIRD.

It won't be the last time you say that, that's for sure. But give it a go. Everyone has a passion, and you never know: this one might be yours too...

11 AVON ST, PORTLAND,
MAINE, USA
WWW.CRYPTOZOOLOGYMUSEUM.COM

International Cryptozoology Museum / USA

WHAT'S THIS PLACE ABOUT?

The name makes it sound like a museum dedicated to death – *au contraire*, this place is a celebration of life. If you ever had any doubt about the existence of Bigfoot, or the yeti, or even the elusive Iceman, this museum will make you... well, slightly less doubtful. Cryptozoology is the 'study of hidden animals', from the Greek word 'kryptos', meaning hidden.

WOW, EXCITING – PROOF OF BIGFOOT!

So it seems. Here, at the world's only cryptozoology museum (we know, the only one – weird, right?) there are exhibits including 'actual hair samples' from the Abominable Snowman and foecal matter from everyone's favourite elusive cryptid, Bigfoot, but also displays about our lesser-known rare and extinct creatures like the coelacanth and thylacine. That's a type of fish and the Tasmanian tiger, for those not up on their strange creatures knowledge.

SOUNDS LIKE FUN, CAN I BRING MY KIDS OR IS IT GOING TO FREAK THEM OUT?

It's totally kid-friendly. The life-sized sculptures of the Crookston Bigfoot, for example, and life-like models of a Sasquatch baby and FeeJee Mermaid are more fun than freaky.

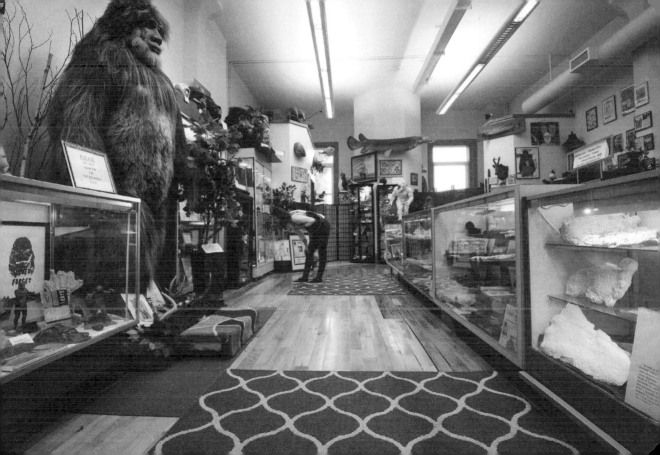

IRILOMETODSKA 2, ZAGREB,
CROATIA
HTTP://BROKENSHIPS.COM

Museum of Broken Relationships / Croatia

THIS SOUNDS LIKE IT'S GOING TO GET UGLY.
If you've ever wondered what becomes of the broken-hearted, wonder no longer – they come here.

HOW INTERESTING CAN OLD LOVE LETTERS AND BLACK AND WHITE PHOTOS BE?
Well here's the thing. The objects on their own wouldn't mean much, but the articles on display are all enhanced by personal short stories that give an insight into each broken relationship, and these vignettes tell a very poignant and universal story of love and loss, but also of strength, resilience and renewal.

SO WHAT SORTS OF THINGS WILL WE SEE?
As you would imagine, there's a wildly eclectic mix. Take, for example, the ominous looking axe head, titled 'An Ex Axe', or the little 'Divorce Day Mad Dwarf' which shows heavy signs of harm. There's a wedding dress, a mobile phone, and a teddy bear, but of all the exhibits the tiny Venetian glass horse captures the museum's sentiment most beautifully. The story of the glass horse tells of an exultant time, a joyful memory and a belief in the healing powers of the future.

YOU'RE BREAKING MY HEART.
Just you wait.

116

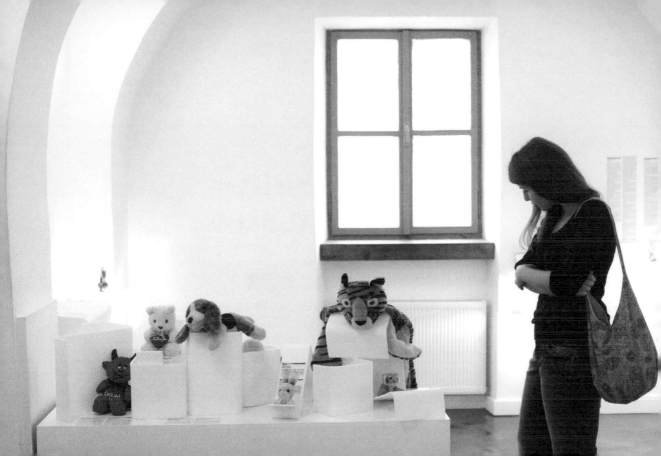

JINGKAI SIDE ROAD, DAXING,
BEIJING, CHINA
PHONE: +86 10 8928 1181

Watermelon Museum / China

ARE YOU HAVING A LAUGH? WATERMELONS?

Who hasn't spent a quiet moment wondering about watermelons? You say to yourself – where did they come from? How are they grown? How many varieties are there? If only all the answers to my questions could be found in one place. Well, BOOM – they can and they are, here at China's only museum devoted entirely to the humble watermelon.

WILL WE JUST BE WANDERING AROUND LOOKING AT WATERMELONS LABELLED IN GLASS CASES?

Hell no, someone obviously decided that the exhibits here could do with some supercharging. Neon lights dance around the wax replicas of numerous different watermelon varieties, there's music pumping in the background, there's even a gigantic fake watermelon hovering over the entrance.

SEEMS LIKE A LOT OF EFFORT FOR A WATERMELON.

Well, its China's favourite summer fruit. There are references to watermelons in ancient poems so the love affair has been alive for many years. If you need some convincing of the watermelon's positive properties then head outside where the garden grows the real thing – you're welcome to give the star attraction a taste test.

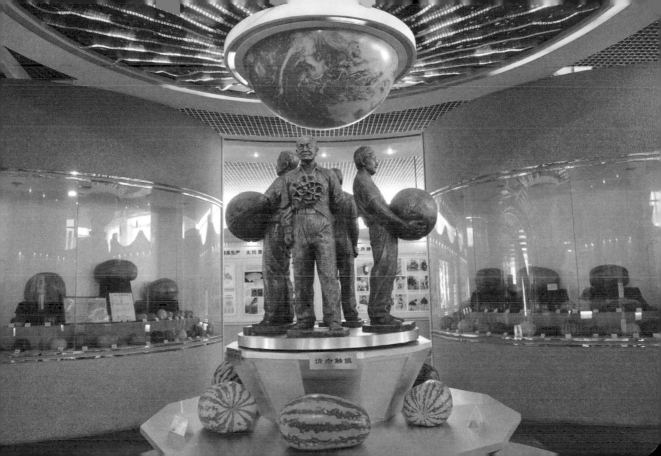

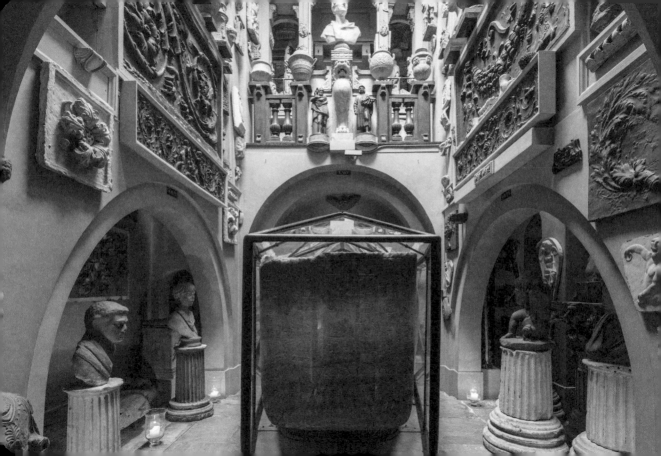

About the authors

Ben Handicott once published travel pictorial and reference books, dreams about, writes about and sometimes even does, travel. He collects bottle caps. For someone else.

Kalya Ryan is a travel writer, editor and keen observer of human quirks and passions. Tasked with exploring the myriad museums of the world, she found the greatest challenge was one of selection; so many mind-blowing, inspiring collections and only 50 spots to award. She also collects good times.

Index

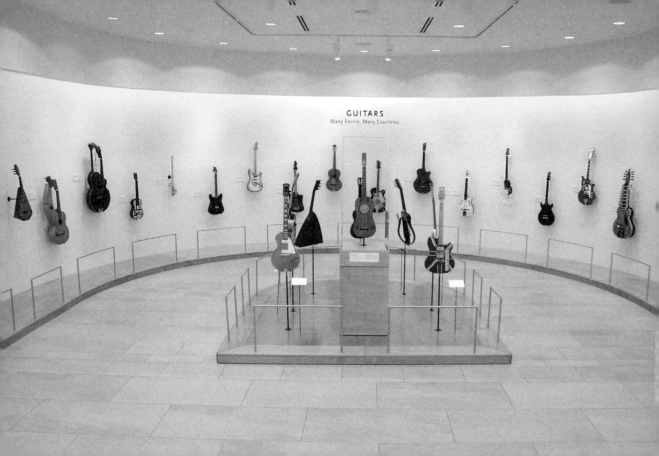

GUITARS
Many Forms, Many Countries

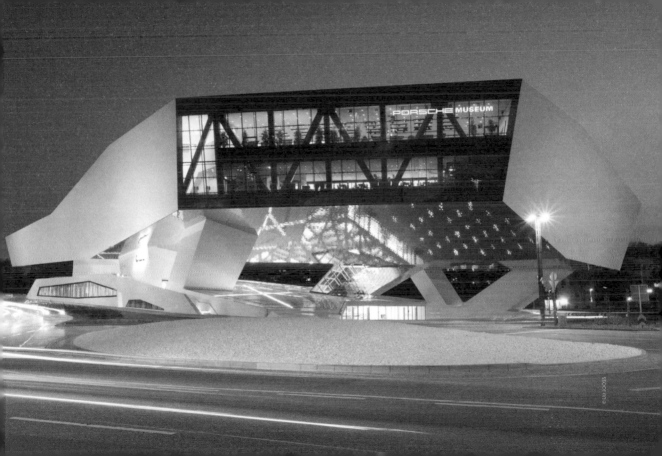

Published in May 2016 by Lonely Planet
Publications Pty Ltd
ABN 36 005 607 983
www.lonelyplanet.com
ISBN 978 1 76034 060 5
© Lonely Planet 2016
Printed in China
10 9 8 7 6 5 4 3 2 1

Written by **Ben Handicott and Kalya Ryan**

Managing Director, Publishing **Piers Pickard**
Associate Publisher **Robin Barton**
Commissioning Editor **Jessica Cole**
Art Direction **Daniel Di Paolo**
Layout Designer **Hayley Warnham**
Editor **Bridget Blair**
Picture Researcher **Christina Webb**
Print Production **Larissa Frost, Nigel Longuet**
Cover image **Sivan Askayo**

Lonely Planet offices
AUSTRALIA
Level 2 & 3, 551 Swanston Street,
Carlton 3053, Victoria, Australia
Phone 03 8379 8000
Email talk2us@lonelyplanet.com.au

USA
150 Linden St, Oakland, CA 94607

Phone 510 250 6400
Email info@lonelyplanet.com

UNITED KINGDOM
240 Blackfriars Road, London SE1 8NW
Phone 020 3771 5100
Email go@lonelyplanet.co.uk